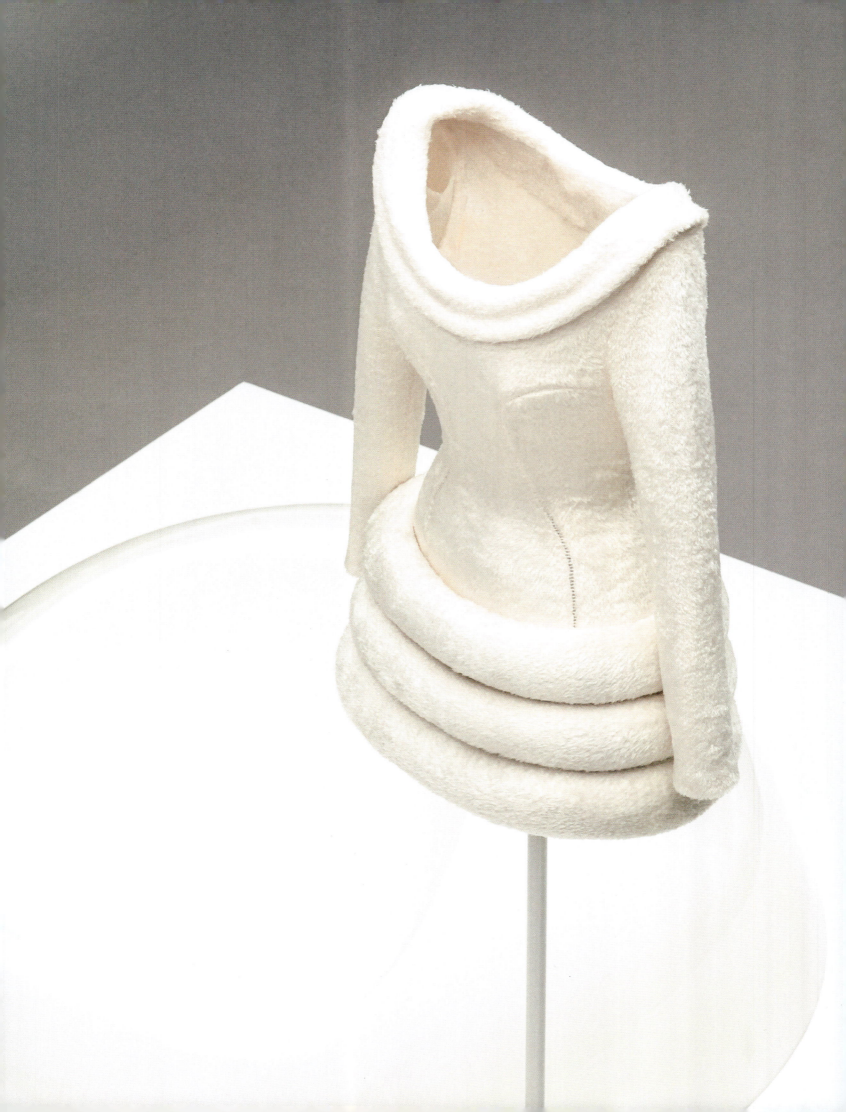

ALAÏA/KURAMATA

LIGHTNESS IN CREATION

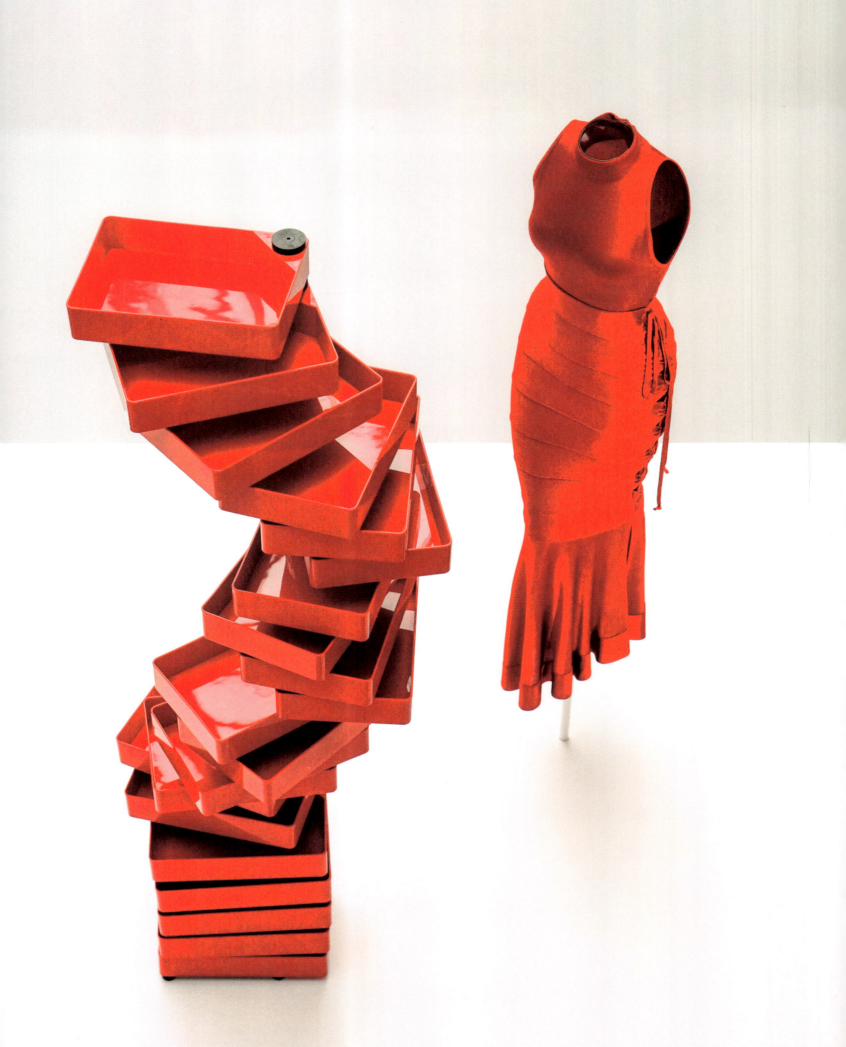

ALAÏA/KURAMATA, LIGHTNESS IN CREATION
By Olivier Saillard

How High the Moon is a steel mesh armchair designed by Shiro Kuramata in 1986. It is one of over thirty pieces that Azzedine Alaïa collected from the 2000s onwards. "To get away from rags", quipped Alaïa, who appreciated Kuramata's light-hearted humour and their shared relationship with sculpture.

"The biggest problem," Kuramata explained, "is gravity. We must think about how to erase it". His pared-back creations aimed at achieving perfection are well-honed responses to the problem of balance in objects. *Glass Chair* (1976), *Broken Glass Table* (1986) and *Twilight Time* (1985) combine the notions of erasure and the memory of a chair or table to multiply their subtracted forms. Whether it be armchairs, lamps or stools, Kuramata's acrylic furniture removes any suggestion of structure and does away with the visual impurity he shunned.

Azzedine Alaïa was a great admirer of Shiro Kuramata, who died in 1991, and hosted an exhibition of his work in his gallery in 2005. He also became a close friend of Kuramata's wife Mieko, who played an essential role in building Alaïa's collection of essential pieces including *Pyramid* (1968), *Luminous Chair* (1969), *OBA-Q* (1972), *Glass Chair* (1976), *How High the Moon* (1986) and *Twilight Time* (1985). Only *Miss Blanche*, the mythical armchair made of acrylic and roses, was missing from the collection, but Alaïa never lost hope of acquiring it one day at auction.

Twenty years later, and for the first time ever, the Azzedine Alaïa Foundation is celebrating one of the greatest designers of his time by associating Shiro Kuramata's work with a careful selection of pieces by Azzedine Alaïa chosen for the materials, forms or approaches they share. The lurex knit of a simple gown responds to the knitted metal mesh of a chair, while the transparent acrylic of a shelf unit echoes the feather-light chiffon of a couture creation.

The way Kuramata made lines disappear and Alaïa's constant quest for masterfully invisible stitching brings their creations together. They have in common formal subtraction and, paradoxically, diversity of composition. Kuramata's *Pyramid* shelving unit (1970) echoes Alaïa's bandage dress, while the frozen folds of the *Oba-Q lamp* (1972) echo those of an evanescent white gown.

Twenty two pieces of furniture and objects designed by Kuramata (1934-91), owned by the Azzedine Alaïa Foundation are presented in the exhibition. In parallel, twenty one couture creations by Azzedine Alaïa demonstrate his poetry of form, his radical tailoring and his refined use of transparency. Imbued with a great sense of lightness, the pieces on display reflect an eagerness for abstraction shared by both artists.

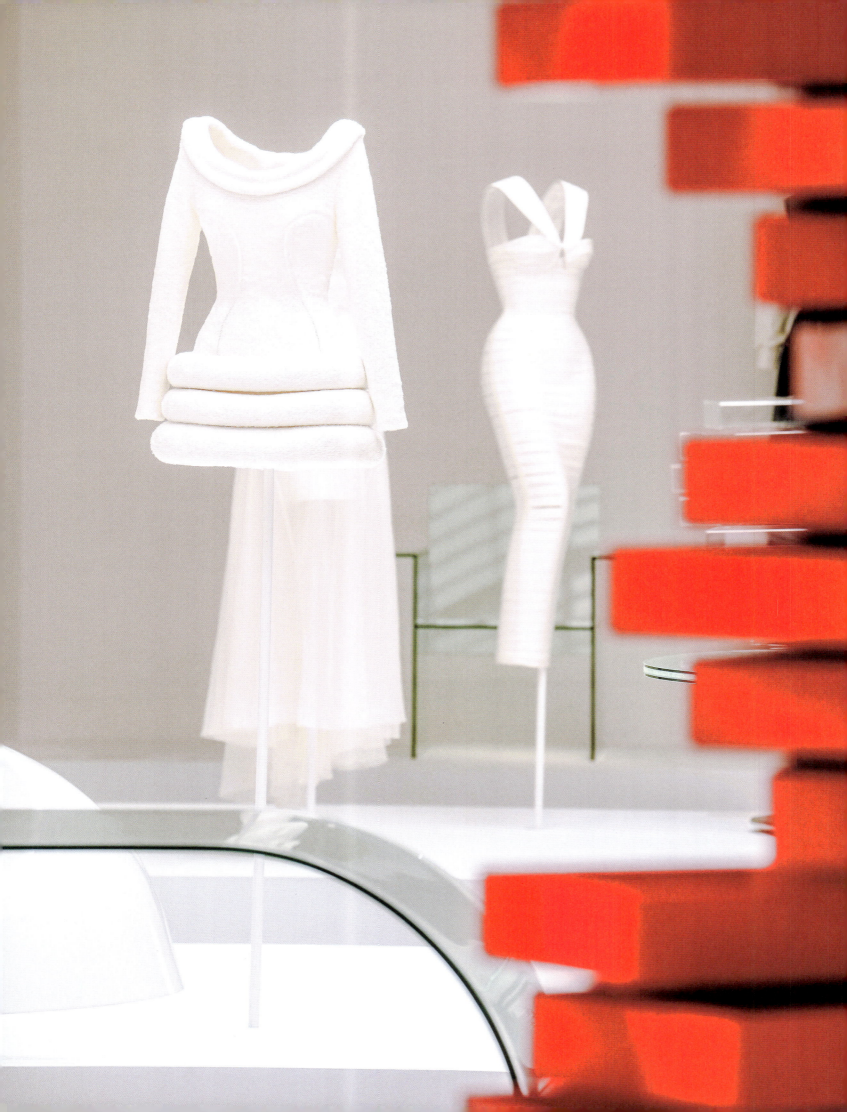

"WITH FOND MEMORIES".
By Mieko Kuramata

Azzedine Alaïa was a distant figure to me, until Carla Sozzani introduced us in Tokyo.

I learned how passionate he was about the work of Shiro. The next time we met was in 2003 in Milan, where 10 Corso Como held a Kuramata show. He offered to exhibit his own collection of Shiro's work in his gallery in Paris, which really touched me.

The exhibition was held in the fall of 2005, showcasing Shiro's representative works from his early years to his last piece *Laputa*, with the exception of *Miss Blanche*. A few pieces had been newly produced in Japan. During preparation, I was impressed by Azzedine's active participation in setting up the show, while keeping an eye on every detail, just as Shiro used to do. One day, he showed us around his private apartement, in the same building as the gallery. I remember his beaming face as he opened the door to the bathroom, which was equipped with two washbasins named *Coup de Foudre* from 1988.

That piece was not commercialized in Japan, but was manufactured and sold briefly in Italy. I was stunned and of course happy to see that Azzedine was actually using it, and was touched once again by his passion for Shiro's work.

Azzedine and Shiro never met, yet I find them quite close. The two of them have brought dreams and wonder to our lives, Azzedine through garments of unprecedented beauty that revealed itself once worn, and Shiro through furniture designed like no one has ever imagined.

In 2005, I realized how similar their approach to work was, and Azzedine became someone very close to me ever since. With this new exhibition, I look forward to experiencing the resonance between their visions through their works.

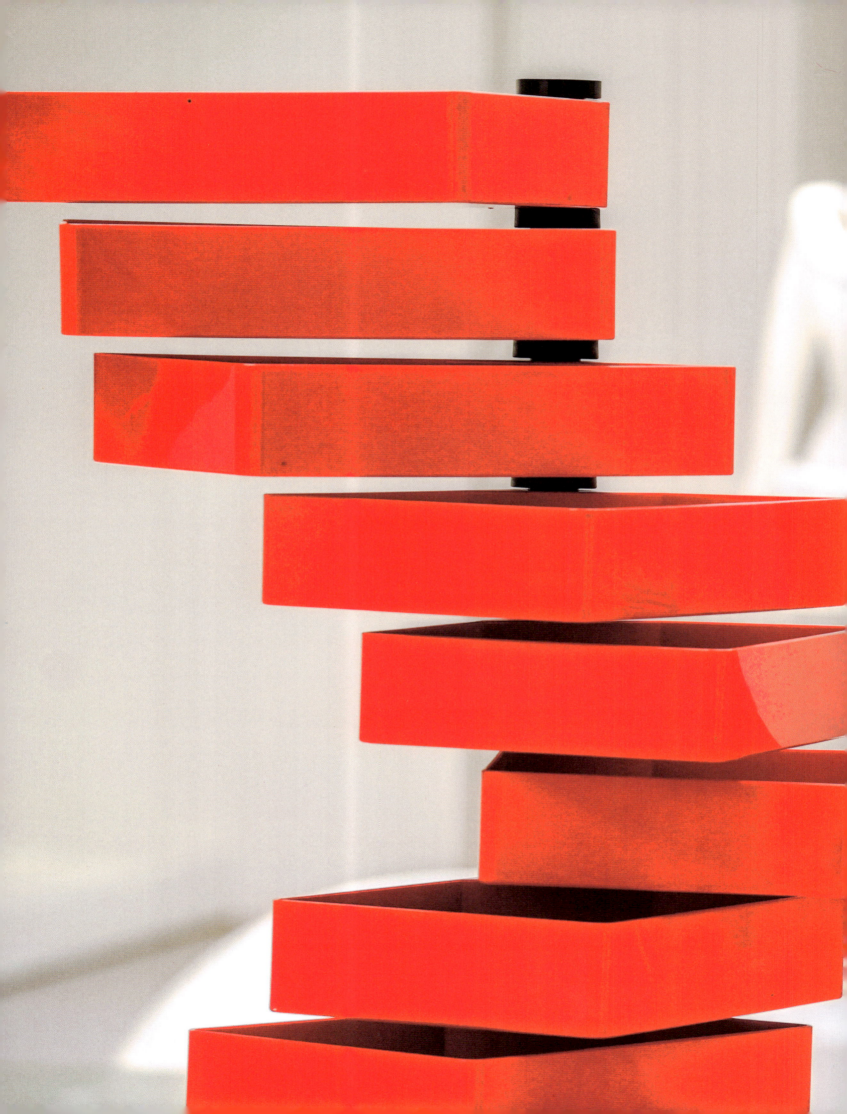

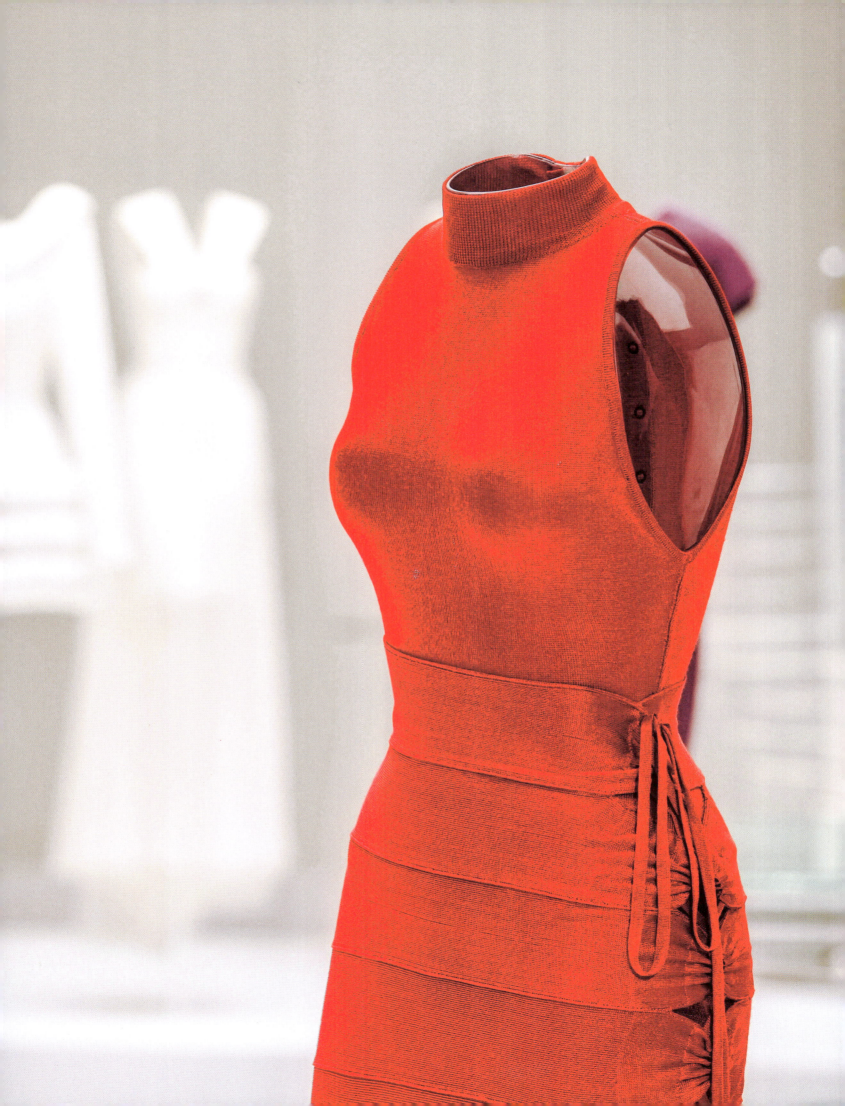

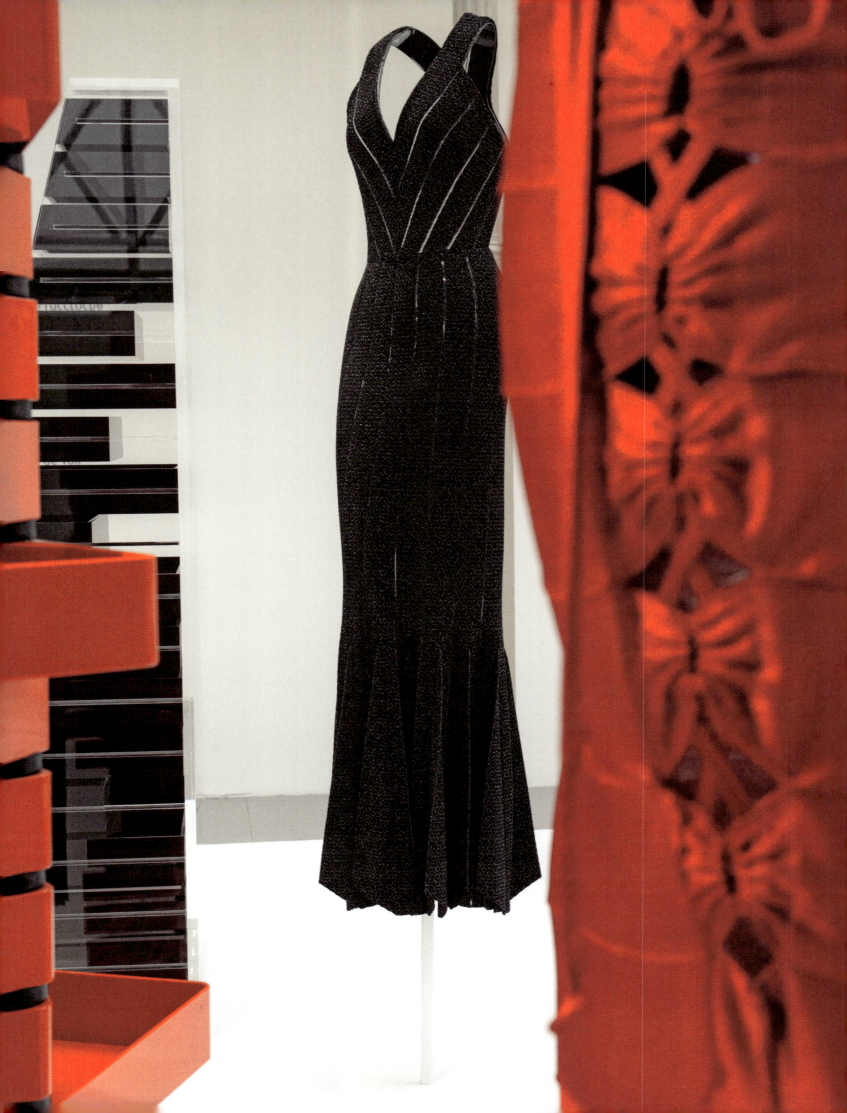

ALAÏA: "WHEN I LIKE AN OBJECT, I'M IN A TRANCE".
By Anne-Marie Fèvre

At Azzedine Alaïa's estate his couture business is a maze of buildings in the Marais district, you can rest on undulating seats by Marc Newson. Have breakfast on a Jean Prouvé table if you're staying in his three-apartment hotel. "And my place is worse than a museum: I have to leave it to rediscover my objects," he laughs. This collector is sometimes exalted: "When I see an object I like, I'm in a trance, it's like voodoo. I don't have a business strategy". So it's hardly surprising that Alaïa opened his gallery to Shiro Kuramata (1934-1991, see opposite) "just for fun". In addition to drawings, he has brought together some thirty major pieces by the Japanese designer, most from his personal treasure trove. Among them, *Comme la lune est haute dans le ciel* (*How High the Moon*, 1986), with its ironic-iconic title, is one of the Tokyo master's emblematic armchairs. This seat, made of expanded steel mesh, is a hazy, veiled volume whose structure is indistinguishable. Similarly, his *Meubles de formes irrégulières* (1970), a series of wiggling chests of drawers, disrupt space and blur vision. "The biggest problem," he explains, "is gravity, and we have to think of a way to erase it".

Kuramata has not been shy about dematerializing industrial components, piercing matter with light, making some of his acrylic solids liquid. Yet his furniture is not obliterated; it captures attention like so many airy derangements, interweaving refined Japanese signs and Western functions. "What I like about Kuramata is the lightness, the humor, and it's very close to sculpture", explains Alaïa, famous for his talent for 'sculpting' women's bodies and a former student at the Beaux-Arts in Tunis.

How did your love of collecting come about?
As a child in Tunis. My grandfather worked in the identity card department. When I went with him, I used to collect the photomatons that had been thrown away. I classified them according to all sorts of criteria: the good-looking, the bad-looking, the blond, the brown, the pretty Italian girls... For years, I stored these countless faces of strangers in boxes.

Where does your accumulative passion for design come from?
In the 60s, I lived in a maid's room lent to me by my friends Simone and Bernard Zehrfuss, an architect. It was entirely furnished by Jean Prouvé. I thought the furniture was beautiful, but I didn't know much about design at the time, and I didn't have any money. Then these friends gave me a bed by Prouvé. I even met him in person, without realizing the importance of his work.

Your first acquisition?
My first piece, which I paid for on credit for years, wasn't design. It was a head sculpture, spotted in a gallery. It's a lifelong friendship. I also have a passion for Chaissac

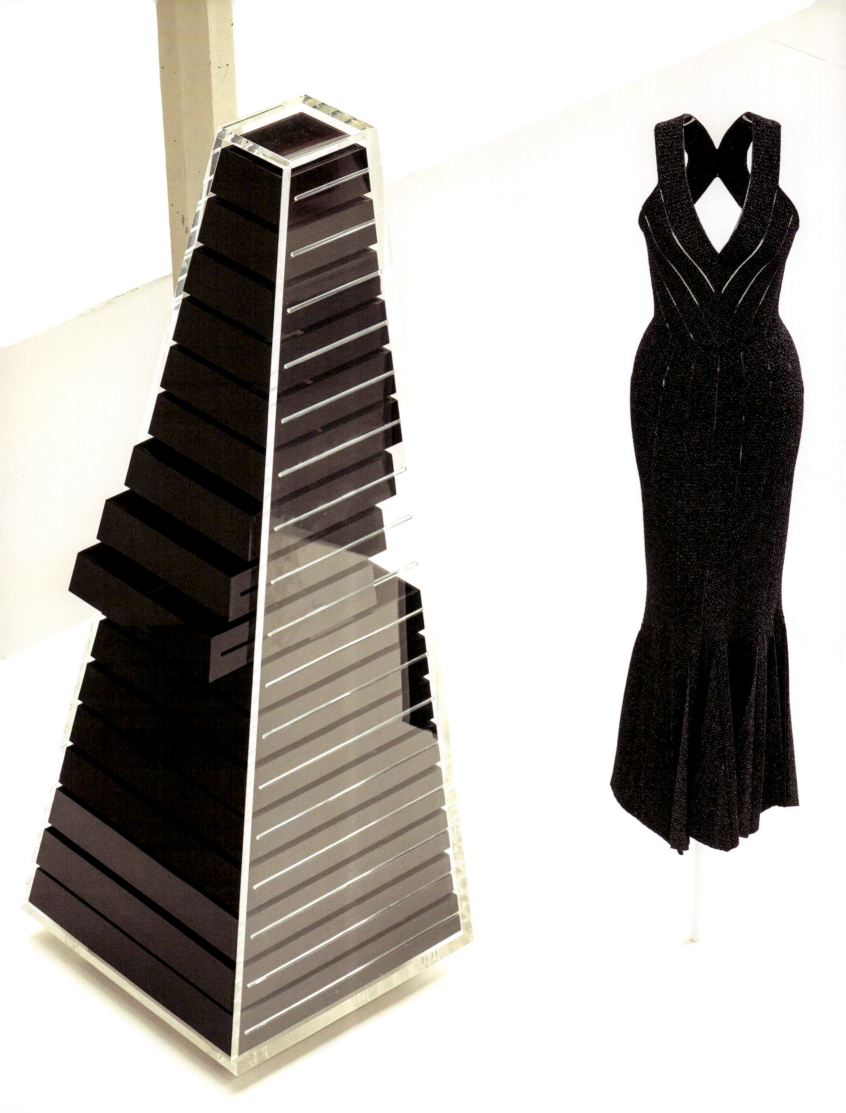

and African art. I gave up Art-Deco. Later, I rediscovered Prouvé and was able to buy his pieces in Clignancourt. I have some Pierre Paulin armchairs and a lot of Kuramata furniture acquired in the 90s. At the same time, I discovered Marc Newson's shapes when he was young. Since then, I've been very close to the gallery owners and collectors Philippe Jousse, Patrick Seguin and Didier Krzentowski, my accomplices.

Why an exhibition? You could keep your nuggets...
It's to get away from rags! Even if, in addition to my own work, it took me two years to prepare, with Madame Kuramata in Japan, who lent me some rare pieces, and with Carla Sozzani, who had already exhibited Kuramata in Milan and gave me the impetus. We need to rediscover this designer who, it's true, gained more recognition in Paris and Italy than in Japan. He participated in the Italian Memphis movement and was good friends with Ettore Sottsass. Getting him out of the small circle of connoisseurs and and having local people and passers-by enjoy his work, that's what I like.

What is your relationship between design and fashion?
All couturiers have always been interested in art and design. Schiaparelli was close to the Surrealists, to Dali. Plastically, we can make correlations. It's true, as journalist Gilles de Bure has written, that one of my corset belts can be compared to a Newson table, a mesh dress to his 1990 *Wicker Chair*.

Are there more interesting things happening in design today than in fashion?
In fashion today, young people don't have the time to be inventive. Four collections a year is impossible for young designers. So we don't see anything new. It's all the same old, vintage stuff. There's no more individual vision like in the 80s, there's a lack of that, the last one was Margiela. Whereas independent designers can still go their own way, spending a year or two on a project.

Are you planning any other exhibitions?
I don't have an answer for everything! I'm very badly organized. With me, you have to imagine what I'm going to do. Invent!

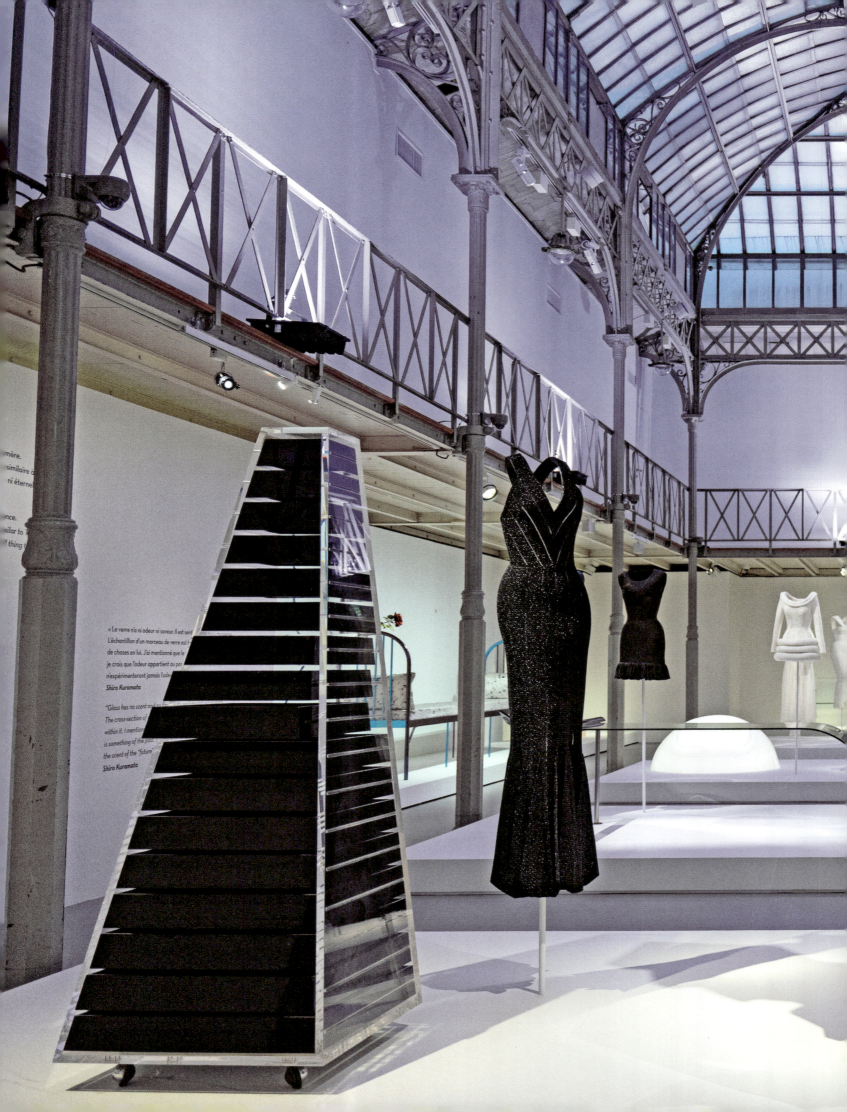

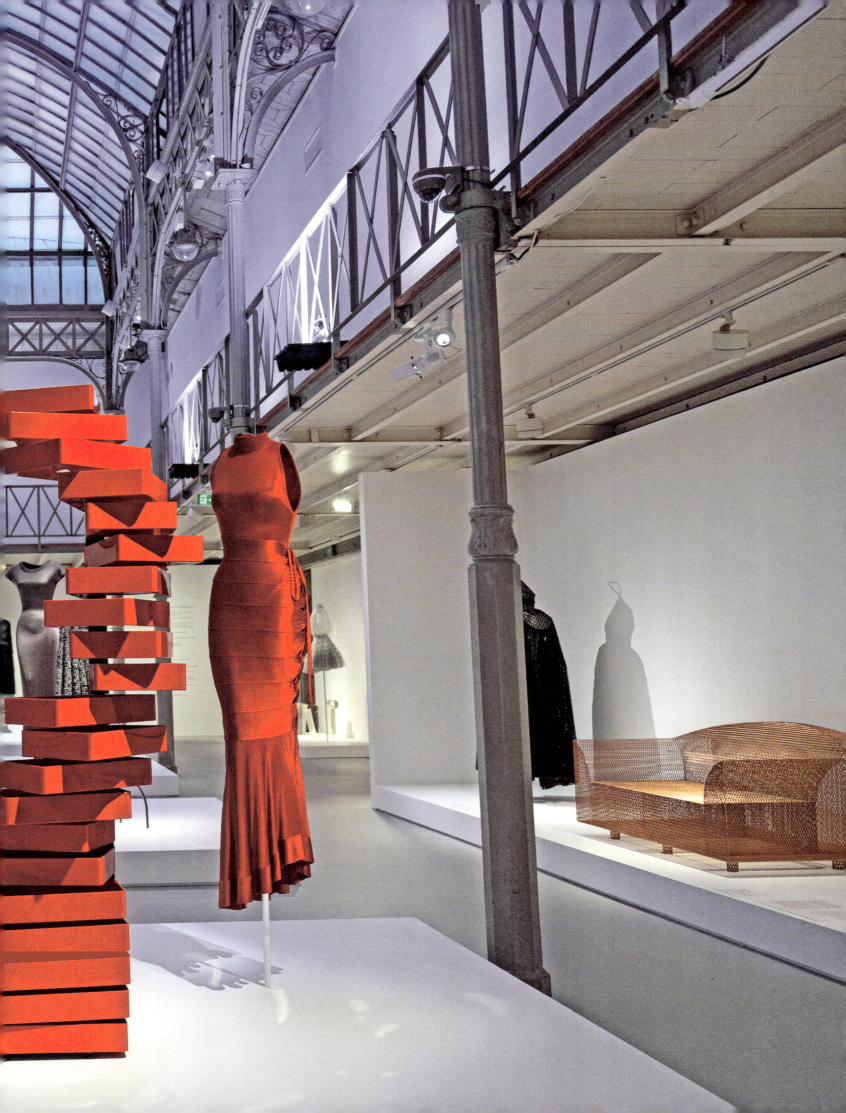

SHIRO KURAMATA, PURPLE SHADOWS
By Andrea Branzi

I have often wondered what causes those purple shadows cast by Shiro's objects, and that limpid but poisonous air exhaled by his environments.
And I have wondered what is that dark light that invades his perfect aquariums.
Shiro always moves between two extreme poles: on one side, he dematerializes the world, as if to alleviate all the pain it causes; on the other, he seems suddenly to immerse himself in matter and to look at it as a metaphor of history, where flotsam and jetsam float colorfully but petrified, like segments of separate and desperate stories. But to talk about Shiro Kuramata, as I see him, entails a confrontation with the profound metaphors that emerge from his work, which smile so devastatingly at us.
To start with, Tokyo must be mentioned, not just as an electronic mega-dream, but as the first metropolis shaped by different and superimposed levels of perception. The first level, which is not perceptible, is that of its public, outer image, of its continually shattered, desultory urban scenery crushed by a thousand glimpses and overlappings; an amniotic liquid of information to be absorbed through the pores of the skin and consumed through ever sharper senses. Kuramata, however, does not belong to this public level of Tokyo. Shiro works inside the other level, that of the inner space, the places, routes, stories, silences and shadows of which this vast city is full to the brim, It is this, more secret and religious level, that produces the indescribable quality of the Tokyo we love.

Tokyo is made that way. It is gray and dead on the outside, crushed and liquid in its streets; but alive and perfumed within, in its stores, bars and halls, between its shelves and stairs and in the semi-darkness of an alternative perfection. Shiro is in there. In the middle of another world. And it is through its great interior architects, islands within an island, that Tokyo crosses the seas. Japanese design at its best stems precisely from here.

In these perfect inner spaces, there is no useless quality, no foregone perfection. The inner spaces of the metropolis pose the biggest challenge to anonymity, to the permanent violation of the provisional. In those brief enclaves, stronger and more stable stories materialize, imaginary zones perfectly described. The places designed by Shiro have an air of enigmatic perfection about them, of smiling but pitiless doubt. In some ways his works seem strangely conficent, in others pessimistic, as if clouded by a broader, more existential perplexity. Shiro Kuramata was one of the first artists to understand the absolute unity, the indivisible compactness of the post-industrial world, a world compounded of numerous seemingly free fragments that are in reality imprisoned in a single block of artificial marble. Kuramata understood that this world was not going to explode, as all the experimentalism of the 1970s thought it would. He realized that the bomb-scare tension of the avant-gardes was directed toward a

utopia by now utterly defeated: the deflagration of the system, the cosmos, the atomic bomb, revolution. He gave up seeking freedom in the disintegration of history. His objects do not yield to the temptation of formal disjointedness. On the contrary they are absolutely mononuclear, unitary, monochromatic and monotextural. But Shiro's anarchic and animating energy has not diminished. Indeed, in some ways it has grown more vigorous. His objects are driven by an inner energy, a spasmodic deformation of signs and surfaces; a dramatic and composed deformation that twists forms without disintegrating objects. If anything, it dematerializes them and transforms them into religious icons, as quiet as gods of a sleep that brings rest but also opens the doors to nightmares... or comforting dreams.

So his energy is the first cold fusion in design, more advanced than the old and uselessly threatening nuclear physics of explosions and, similarly, perhaps impossible. In the sense that cold fusion is more the fruit of the philosophy of science than of scientific reality. But for this very reason it is more up-to-date and modern.

In the work of Shiro, a true anarchic and cold Japanese, I see one of the first mature examples of the Second Modernity; of that modernity which has no scientific or rational foundation at all (at least according to the old definitions) but is identified rather with zones of the imaginary, with a great symbolic and civilized convention.

It is a conventional, imperfect, approximate, inadequate modernity, forever in crisis, and precisely for this reason continually expanding, dilated by new manners, new sensibilities, new perceptions.

It is a symbolic modernity, and for this selfsame reason intended for the slow time of history. It is a modernity suitable for the revolution of the senses, for the profound, ever more profound qualities produced by the skin of reality, by the surface of phenomena; a modernity that springs precisely from man's imperfection, no longer regarded as original sin, but as the capacity to grow, to produce revolutionary energy for the species. Insects are perfect, not man. Precisely his inadequacy, his suffering and his capacity to react to the environment, are what produce history.

Art moreover, in this process, helps him to contemplate his inadequacy and to imagine a different, perhaps unattainable, but for this very reason fascinating and stimulating world. In this century, art and design have, as Shiro does, left many bitter tastes in our mouths. Like treatment based on homeopathic herbs, or poisonous drinks, they have also made us stronger.

Because the future is better. Or maybe also worse. It seems to me that, for Shiro, both prospects are perfectly possible and not contradictory, perhaps because he, too, believes that the future will be absolutely similar to the present.

He believes that progress exists, but that it also always produces its own opposite. Thus more order produces more anarchy, advanced technology more metaphysics, light more shade.

The question, therefore, is not to find comprehensive solutions, but local balances, difficult ecologies within the artificial world. Like roses that never die, immersed in a solid liquid.

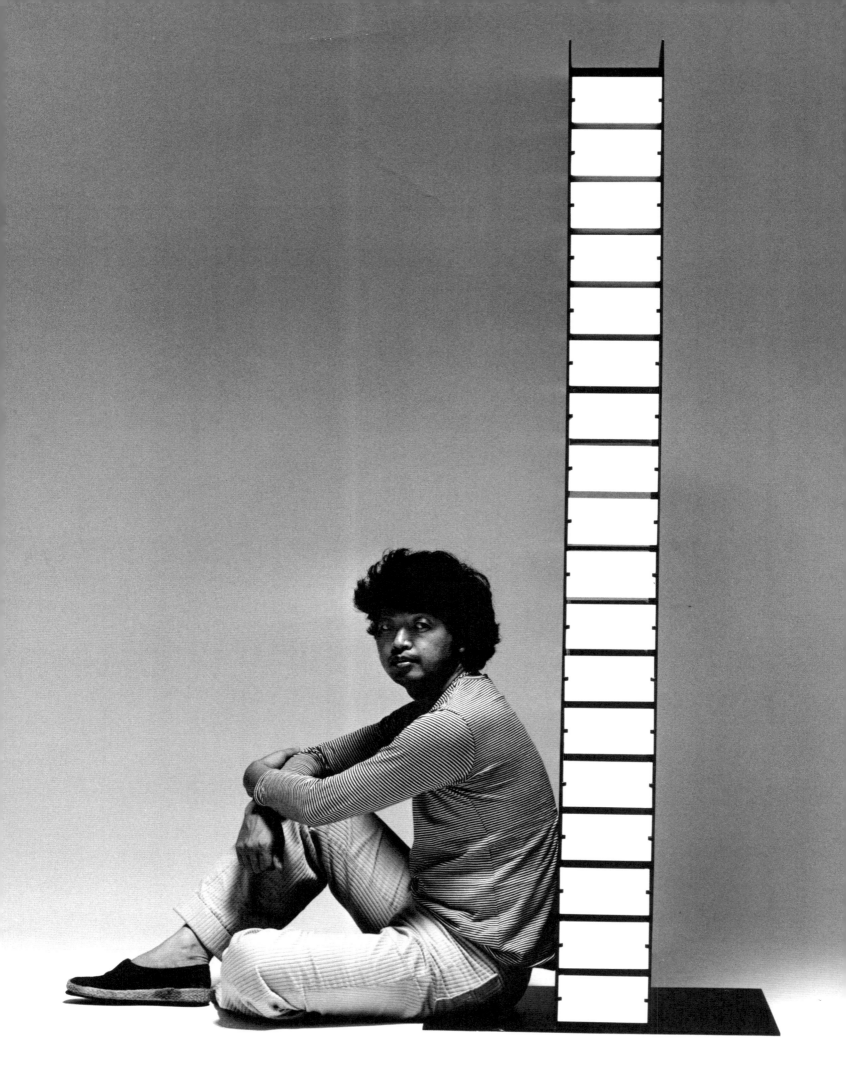

AN INTERSECTION OF GENERATIONS
By Tadao Ando

Kuramata passed away suddenly in 1991 at the young age of 56. It was as if he had disappeared like the wind. Sottsass died sixteen years later, after a career that lasted until he was 90 years old. These two designers work, which was to create dreams, gave form to new concepts of design during the upheavals of the 20th century.

Ettore Sottsass. For us members of the younger generation aspiring to creative work in the latter 1960s - when world itself was on the verge of transformation in Europe, America and even Japan - the Italian design scene that we glimpsed in the few foreign design magazines available to us seemed to shine with the brilliance of an entirely different existence. One of the most stimulating designs all was the work of Ettore Sottsass.

I believe the first place I discovered Sottsass's work was in the magazine Domus, in an article about his red portable typewriter *Valentine* that Olivetti put out in 1969. I bought that pure red typewriter right away and started using it in the office I had just opened. Sottsass designs have an ultimate freshness devoid of extraneous elements, and provide great inspiration to me. Sottsass became highly recognized in Japan in the 1980s, about the time he formed the Memphis group, and was accepted enthusiastically as a symbol of the fashionable "post-modernist movement". Certainly Sottsass design which had expanded expressive freedom through the use of undulating forms with new materials and vibrant colorings, was fully in tune with the feeling of the age. The design philosophy behind such created objects, however, was the polar opposite of consumerism, and sought to communicate something imperceptible to the world through the creative act. Ettore Sottsass was more troubled than anyone by the gap existing between those two orientations. I believe that distress manifested itself as the depth of Sottsass's unfading design.

Shiro Kuramata: Shiro Kuramata respected Ettore Sottsass as his sole mentor, and was one of his life-long friends. Sottsass had a deep appreciation of Kuramata's genius and his sense of humanity. He perhaps grieved more than anyone at Kuramata's much too early death. When I was in my 20s I had the good fortune to become directly acquainted with Kuramata when he went freelance in the mid 60s. It was in a tearoom in Shinjyuku, Tokyo when I first met him through our mutual friend, Kuniharu Sakumoto, an up-and-coming interior photographer.

Tokyo was then chaotic with excitement due to the Tokyo Olympics. Kuramata and I happened to end up in the same place on numerous occasions, and in the '80s I was blessed with opportunities to work with him when he elaborated the interiors and furniture for shops and houses that I had designed.

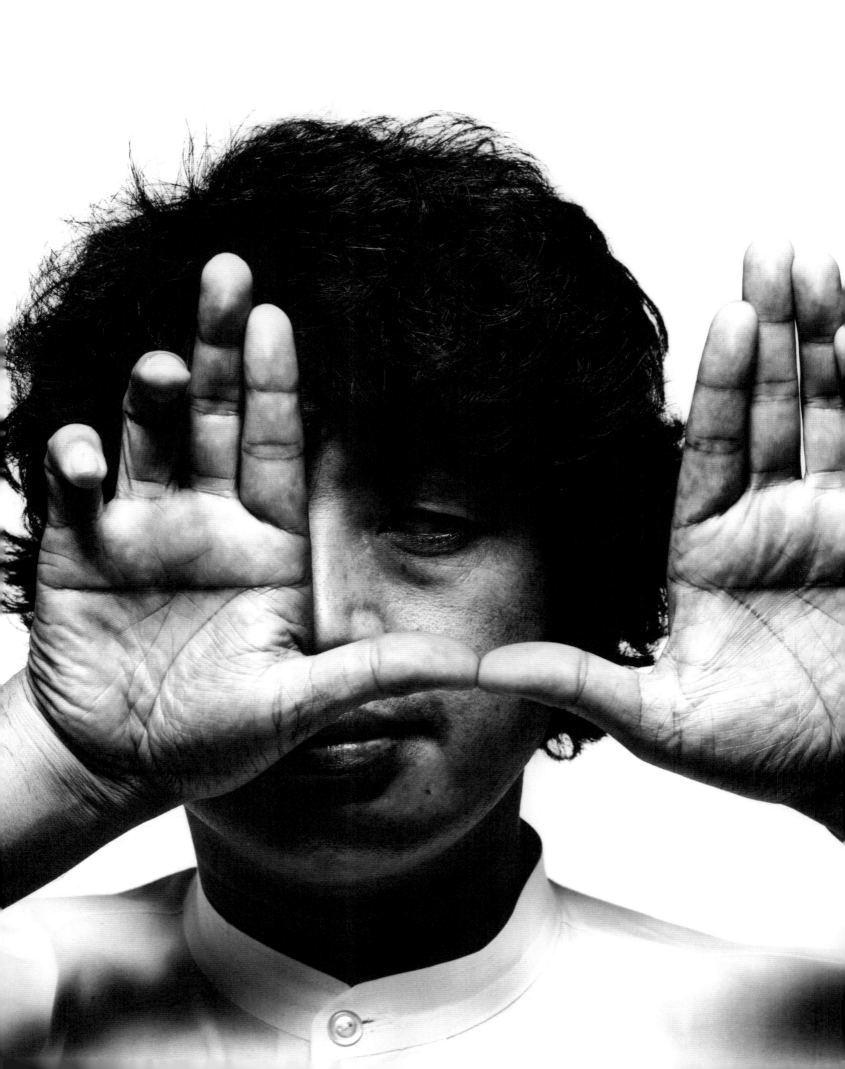

According to this exhibition's organizer, Issey Miyake, an explorer of expressive worlds in the earnest pursuit of beauty and a creator who enjoys the deep friendship and respect of such world-class creators as Javacheff Christo and Irving Penn, the work of Shiro Kuramata "praises eternal beauty". For me, an architect who attempts expression in a domain that tends to be heavily constrained by reality and who deals closely with social realities, Kuramata's work seems like a fantastic world of dreams. His interiors and furniture realize abstract images through his surprising tenacity and the use of unconventional materials and forms. His lifelong work is symbolized by resolute experiments that inject the concept of perfect transparency and weightlessness liberated from functionality into the very real functional objects that are furniture pieces.

Today, *Miss Blanche*, named after Tennessee Williams' masterpiece heroine with its plastic roses imbedded in transparent acrylic sits in my room. Gazing at its unrealistic appearance, which seems to have captured a moment in the flow of time, I realized that Kuramata was attempting to bring an imaginary world into the reality of our daily lives. Kuramata's creations are beautiful and ephemeral precisely because they provide a glimpse into the world of fiction and dreams. The appeal of Kuramata's works is on one hand precisely the conceptual nature, while on the other its an abundant gentleness that deals with vague human feeling. Even while employing cold, inorganic materials, they sublimate into something that possesses the pulse of organic life.

And that probably comes from the human gentleness of Kuramata himself. In fact, I have learned many things from the fine human character of Shiro Kuramata. An introduction to the work of these two rare creators Ettore Sottsass and Shiro Kuramata, this exhibition was planned by Issey in order to inspire contemplation of the universal human questions, "What is it to live? What is it to create?" and "Why do we create?". The works that Sottsass and Kuramata have bequeathed to us, even if the objects themselves have deteriorated physically, possess at their essence ideas and a spirit that will continue to sate for eternity. The immortality of this spirit is crucial for our contemporary society that tends to become swallowed up by systems and lose sight of the power of life.

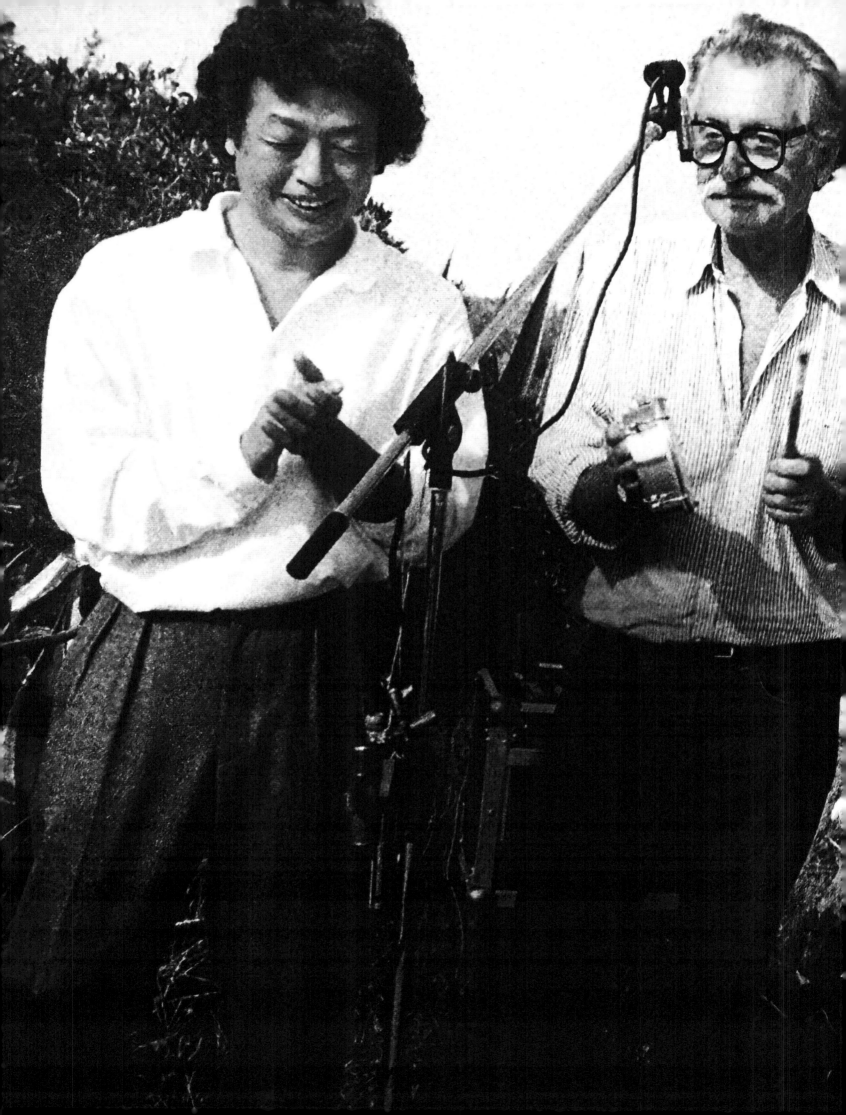

"IT'S ALWAYS SNOWING WHEN I WRITE TO YOU".
By Ettore Sottsass

Shiro Kuramata's work is replete with the ancient and fascinating history of Japanese decorative arts and the modern eagerness for Japanese simplicity and structural simplicity that has strongly influenced the dogma of "form follows function".

More than the pieces themselves, what's important is their stories, which are connected by the continuous thread of non-materialisation. "My strongest wish is to feel free of all gravity, of all ties," he declared; "I want to float". This approach imbues all of his work with a kind of spiritual quest. His attempts to defy gravity find formal expression in transparent materials such as glass, acrylic and metal mesh, as well as in his experiments with the incorporation of light. By using these materials, he explores links between lightness and gravity, matter and non-matter. These relationships shimmer in his designs, producing a calm, contemplative atmosphere redolent with gentle aesthetic humanity and a refined sense of poetry.

The poetic aspect of Shiro Kuramata's creations underscores their character in both art and design. Function takes second place when you sit on his chairs: it is possible to appreciate his work in purely visual terms. The feathers and red roses floating harmoniously and eternally in the acrylic create a feeling of profound aesthetic pleasure that reaches the essence of our souls.

His chairs are sculptural but functional, his materials are man-made yet made by hand, his skill is human yet spiritual, his temperament calm yet determined. How we miss him: he passed away so young. And yet his work continues to evoke the feeling of wonder and admiration that only a true artist and designer can inspire, "leaving the world a better place than when he entered it".

"In the Japanese language there is the word "音色"(neiro) meaning "tone" in English, comprised of the characters "音" (sound) and "色"(color). It is a word that I most cherish. What fascinates me the most is seeing and feeling colors in the transparent world of sound, and the relief that comes from the ability to confirm, to feel and to think about colors when looking at transparent objects. I exercise my imagination in these two infinite worlds of color".
Shiro Kuramata

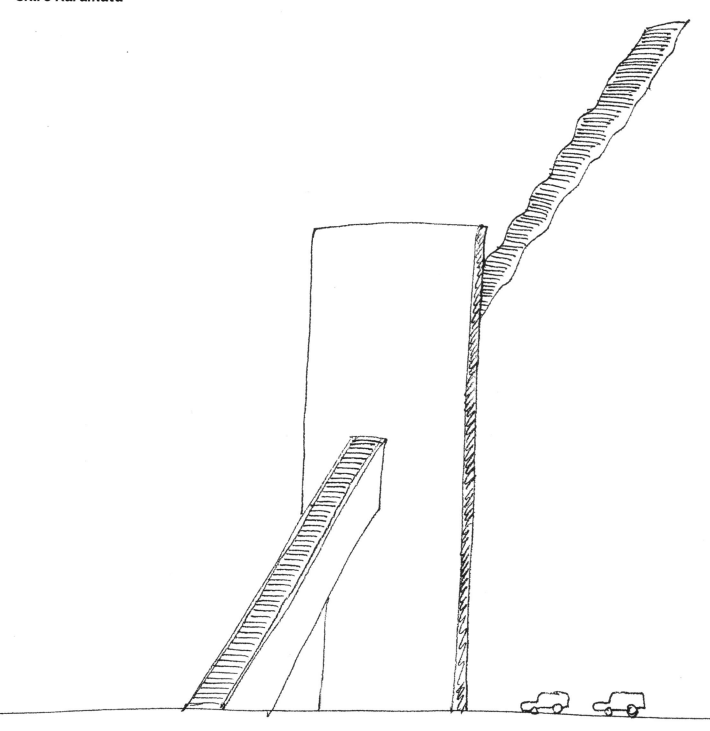

SHIRO KURAMATA
By Barbara Radice

Shiro and I are astrological twins. Born on the same day and in the same month ten years apart. Instant passion and understanding for almost all the same things.

Shiro has told me and written the most extraordinary things that anyone could want to hear, always. And Shiro is with me always. When passed away, suddenly, wretchedly, I was told on the phone and I started screaming. I couldn't stop! Ettore and I sent two hundred red roses to Tokyo.

Shiro considered Ettore his Master and when we were in Tokyo he was by our side from morning to night the whole time. Very few people have been so close to my soul.

I will tell two or three stories.

1 - One day Shiro told me that he wanted me to know a secret word (which I don't remember now). I don't even know if it was real or made up! He said it was a 'Chinese' word, so secret that he almost didn't dare pronounce it, a kind of 'adjective' that could be said, very rarely, about very few people (or even things?) and that it meant, this adjective, that the person to whom it was attributed was someone so special that he was always right, always truly right.
Even when wrong - was right; even when wrong was so right and in short was always so right and on top of everything, etc., that it was very difficult to even talk about it and in fact this word was so rare that it had become difficult to use. It was said to have been heard only a couple of times in the court of I don't know which emperor.

2 - The second thing I want to remember he told me on the phone a few days before his death. On the phone we were talking about moving the opening date of a solo exhibition he was to hold in Milan. Shiro, without even asking about times or places or dates said: 'I don't care, do as you think and where you want. I do the exhibition just to know what you will write'.
That's what I write Shiro! I write what you said, what you told me. You are as close as you have always been, alarmingly!

3 - If I find the drawing of your last letter I will publish it, if not I will tell it, here, now. You drew a snowman and next to it you wrote:
'It's always snowing when I write to you!'

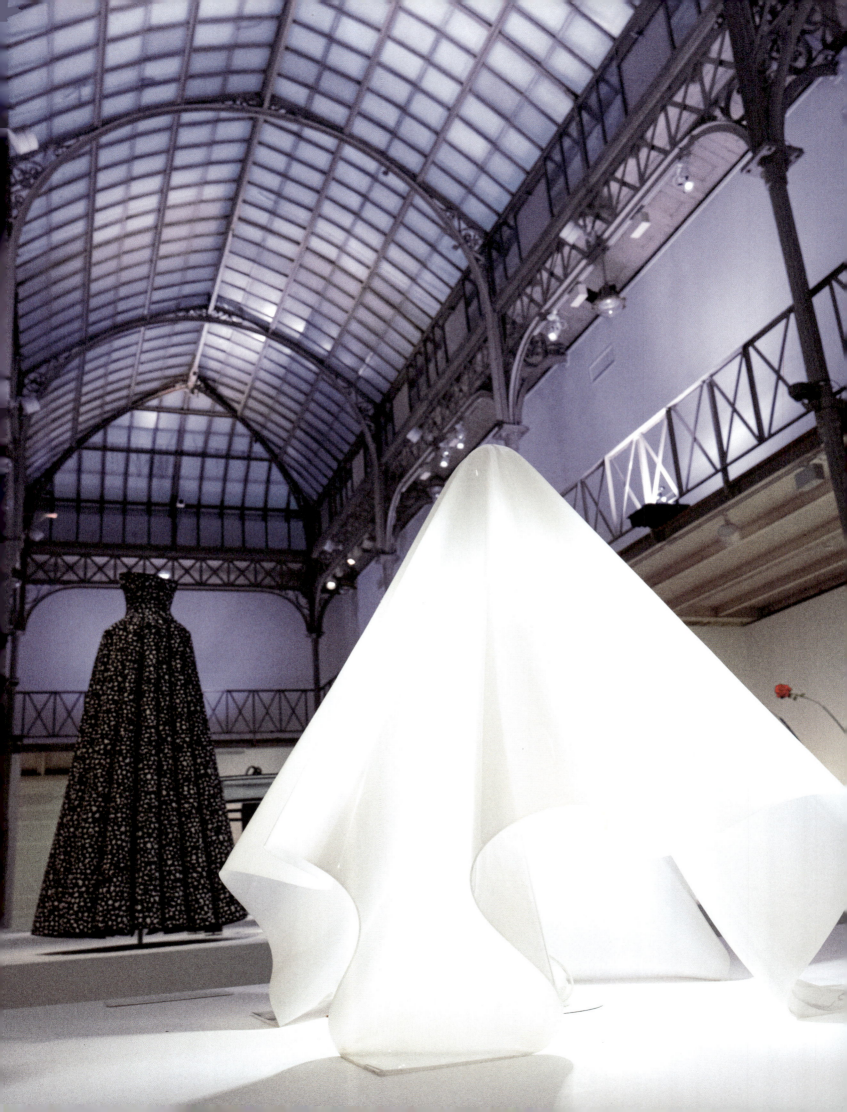

"I'm interested in artificial materials such as glass, plastic, aluminium and so on.
Those are the ones that do not exude a sense of time passing,
they do not rust or stain with age".
Shiro Kuramata

"I use the simplest fabrics, but they can become revolutionary
if you understand their potential. It's not about the material itself,
but how you work with it to shape the body".
Azzedine Alaïa

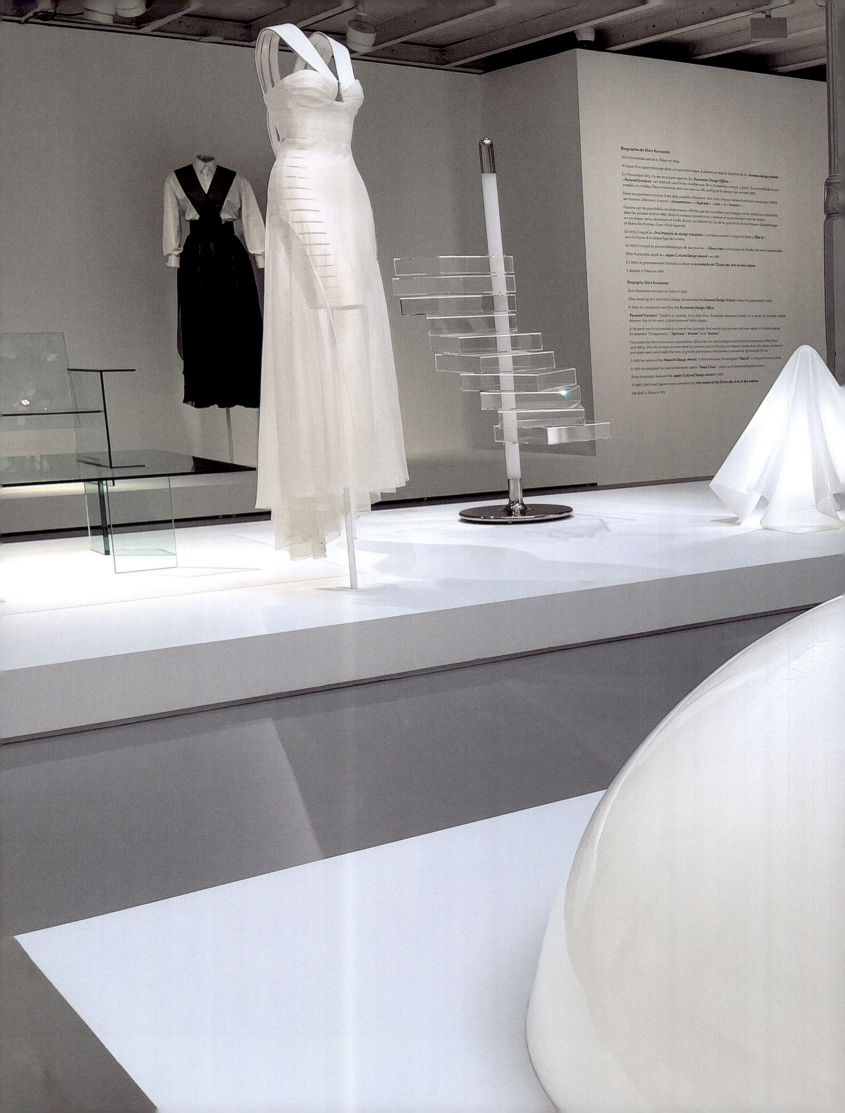

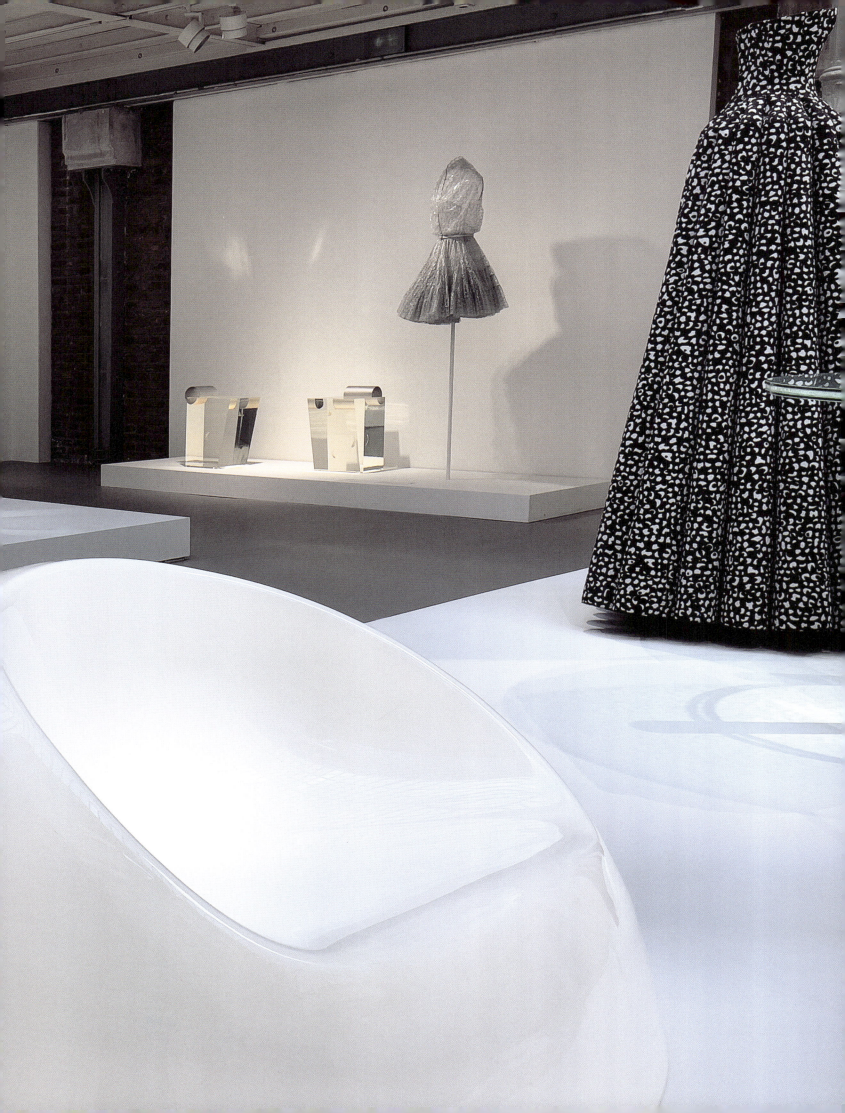

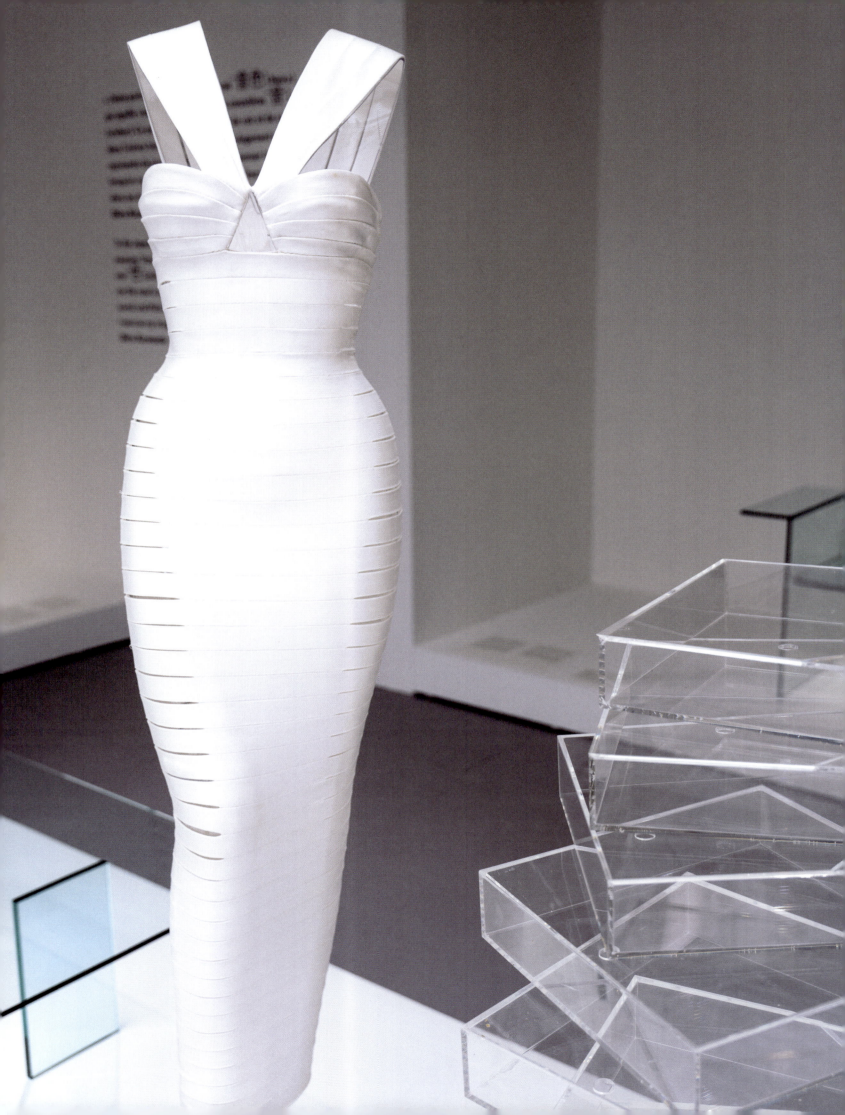

"There are two ways in which I usually conceive an idea.
One is to start from zero, to take away every bit of a "thing" that lingers around "that object". The other way is to ask "why", and to keep throwing the same simple questions at that "thing".
Shiro Kuramata

"For me, creation begins when I start working with the fabric.
It is a slow process, like sculpting. I work directly on the body, and from there, the idea evolves. The fabric is the starting point. I let the material speak to me, and guide the creation".
Azzedine Alaïa

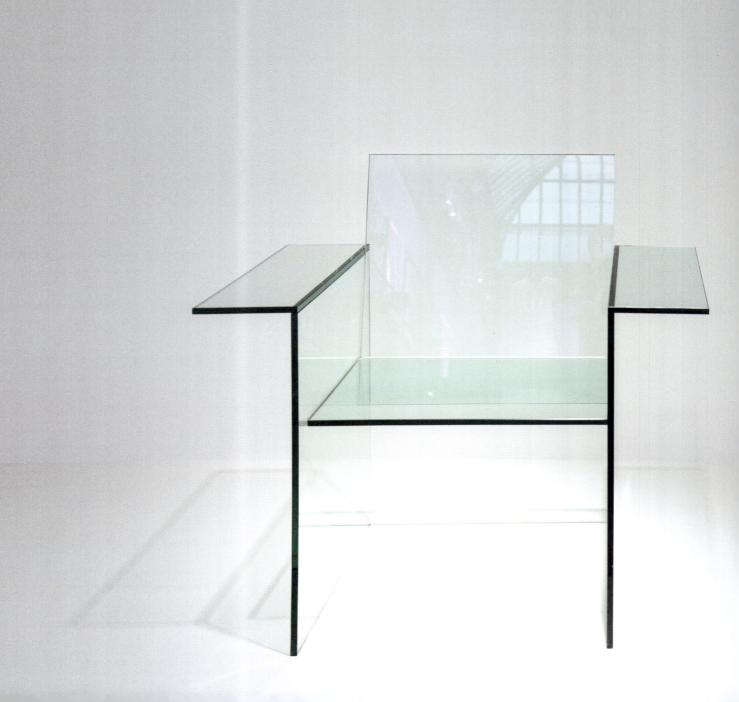

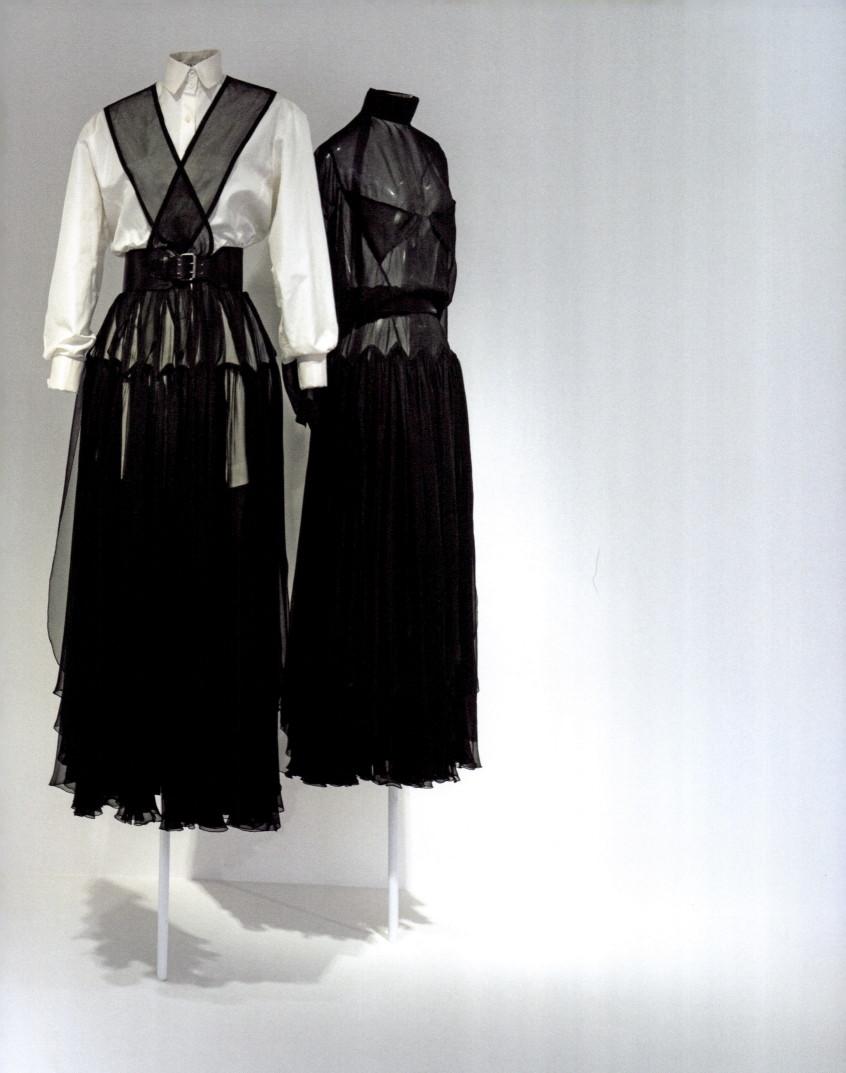

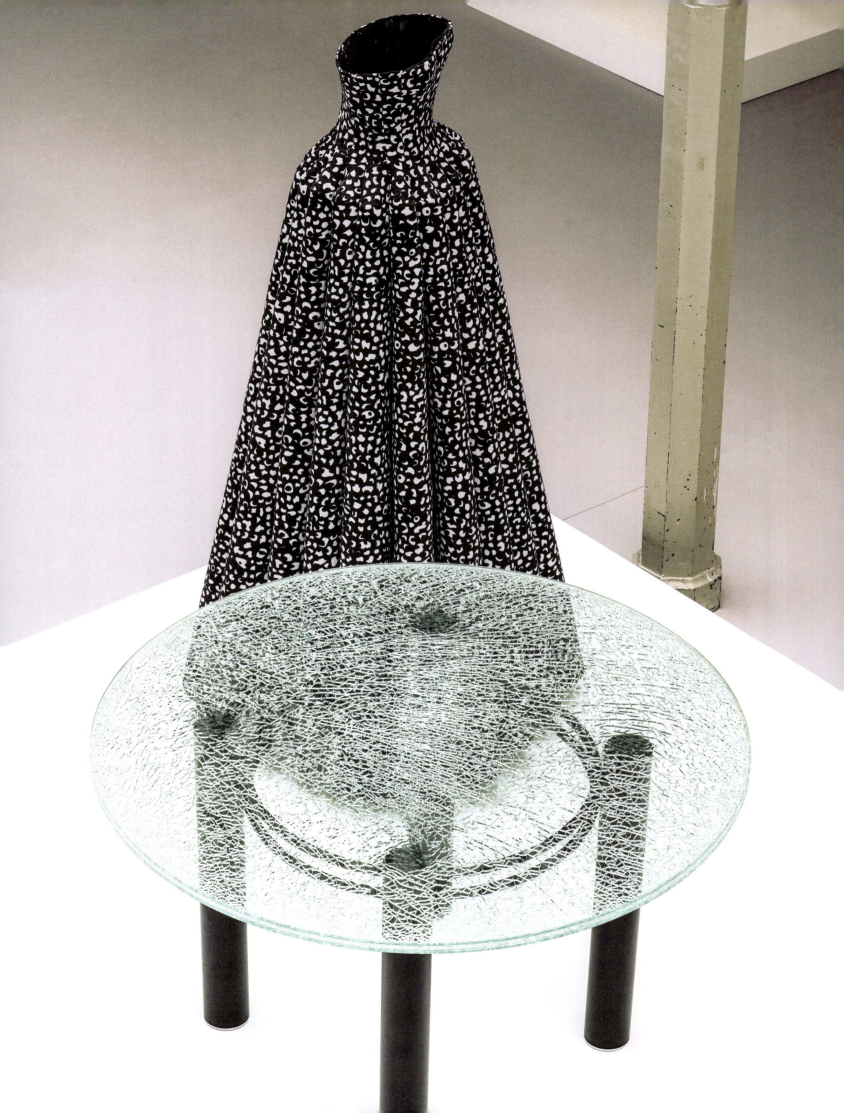

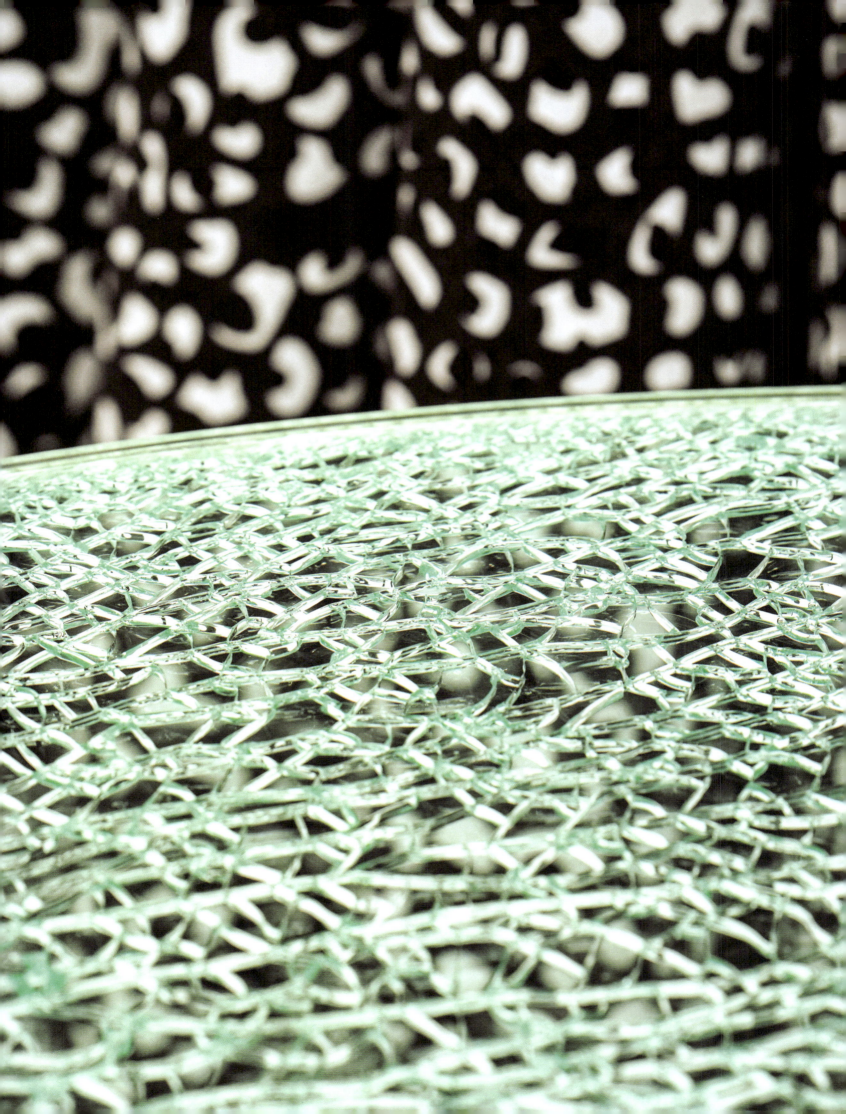

"Glass has no scent and no flavour, it is sensual yet modern.
The cross-section of a sheet of glass is beautiful, it contains everything
within it. I mentioned that glass has no scent, but I think scent
is something of the past. Humans never experience
the scent of the "future".
Shiro Kuramata

"This may be slightly off topic, but the other day I went swimming on an island
down south. At the time, I was lying on the beach and staring blankly at the ocean.
As I watched the waves, they reminded me of the cross-section of glass,
and I was enticed by the sheer beauty of it all. I gained the feeling that the 'past'
and 'future' in some way or another coexisted within the cross-section of glass. In contrast,
the flat surface of sheet glass is a manifestation of the 'present'. For example, glass
can break when it is inflicted with some kind of force, and as soon as it breaks,
it becomes the past (it is no longer 'extant'). This is what I find interesting.
Furthermore, glass as a material, has neither smell nor taste. Nevertheless, it is
also emotional, and is an expression of 'modernity'. In any case, cross-sectional
surfaces are extremely beautiful, and I feel that they contain everything.
As I mentioned earlier, glass is odorless. I somehow feel that smells are a thing
of the 'past'. I don't think people can smell the 'future', but people often
remember smells of the 'past'."
Shiro Kuramata

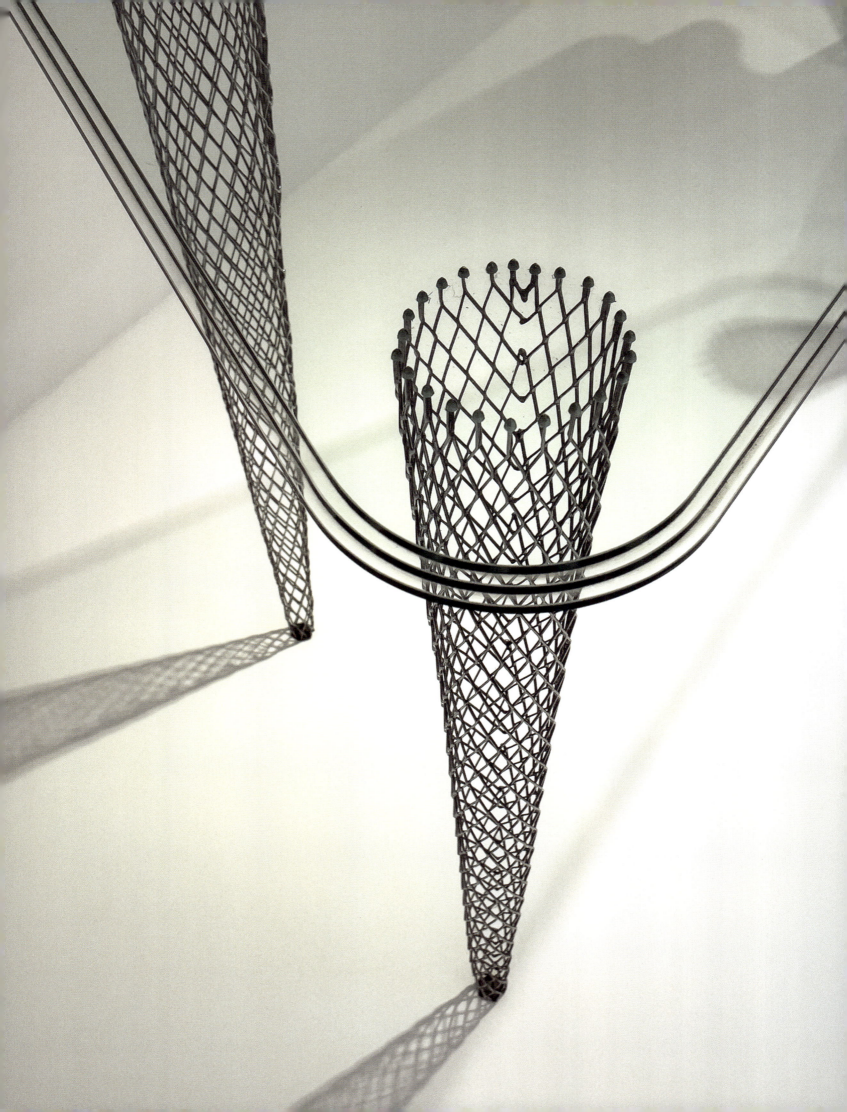

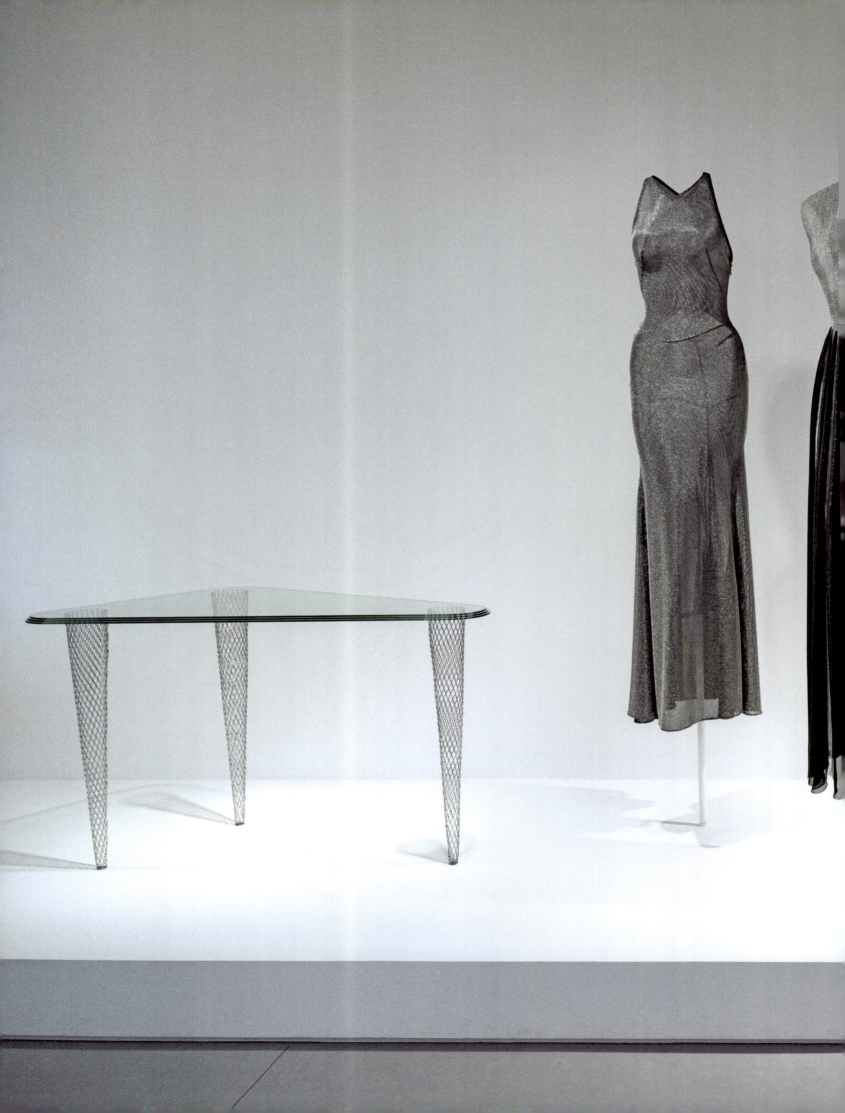

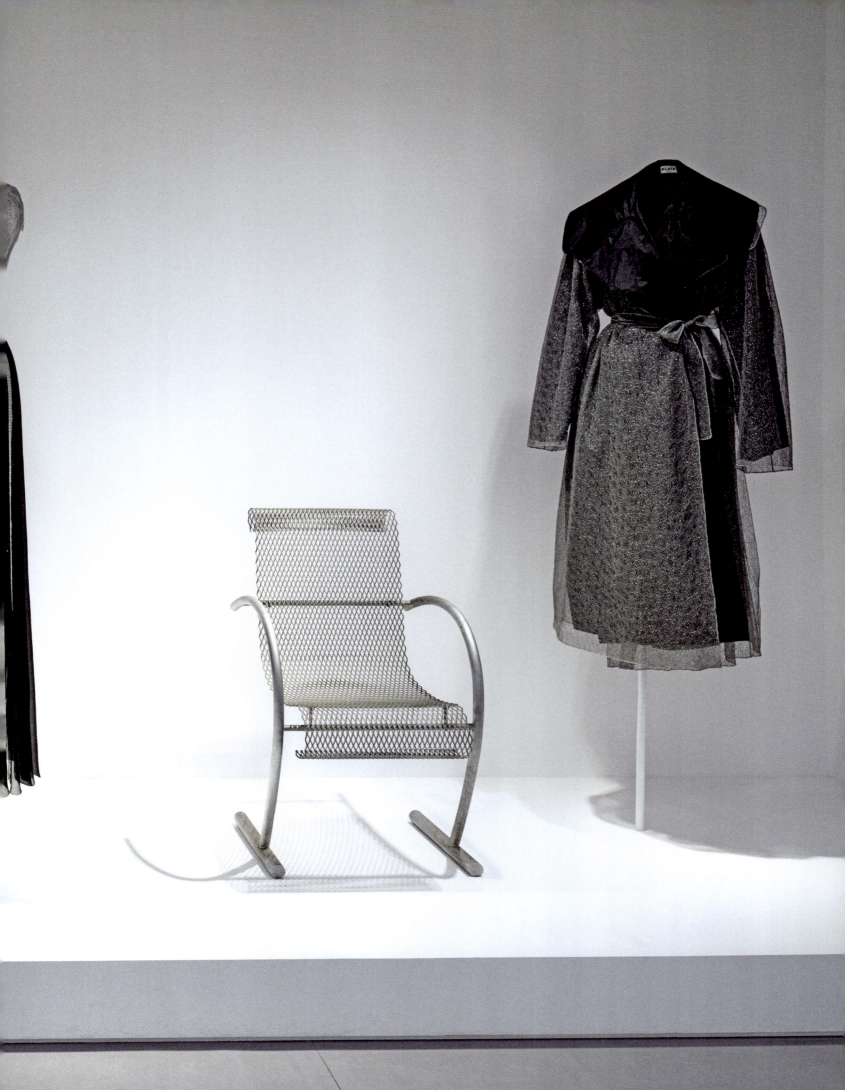

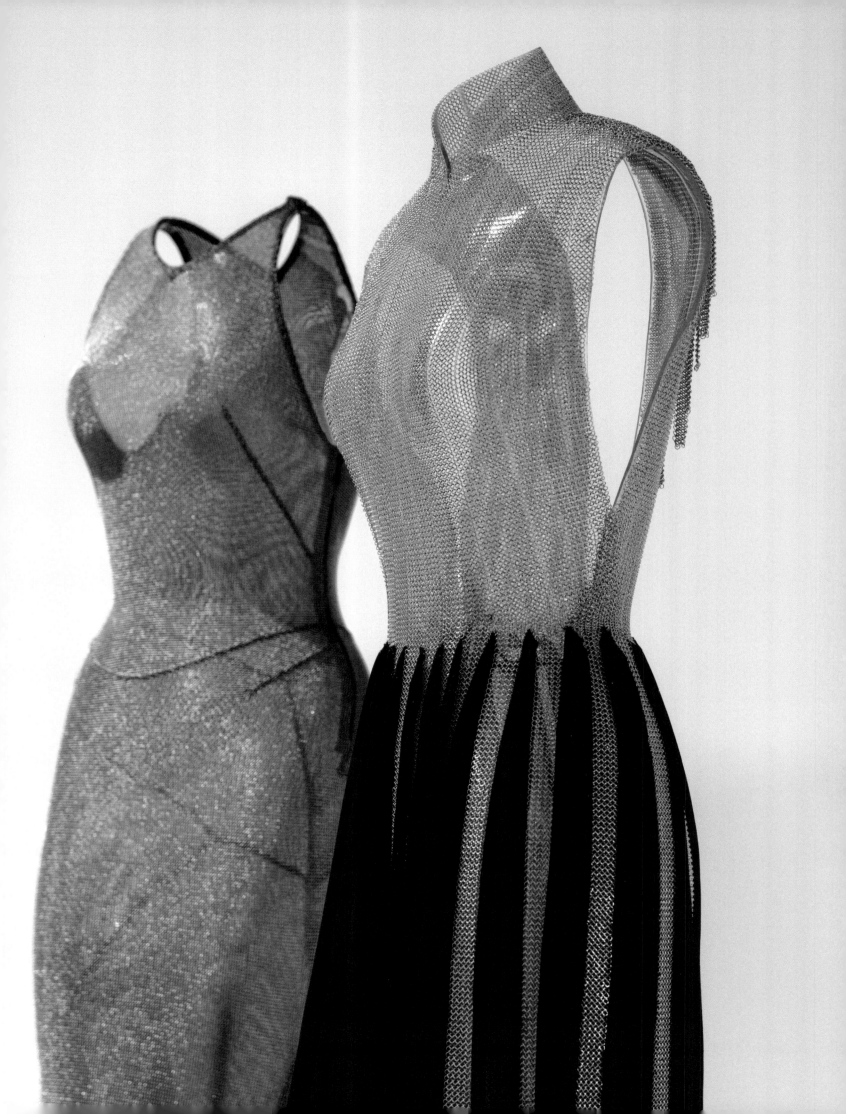

"Metal allows me to push the boundaries of what fabric can do.
It's about creating structure and strength while still embracing the body's curves.
With metal, I can sculpt forms that hold their shape, yet move with the wearer,
merging art and functionality in a way that other materials cannot achieve".
Azzedine Alaïa

"I have a strong desire to escape from the forces of gravitation, to free myself from gravity
and float free. I continue to hold onto the naive hope that only when we are freed from
conventions, established concepts and ideas, and all kinds of constructs that have long been
attached to this earth, will we be able to gain freedom in the true sense of the word".
Shiro Kuramata

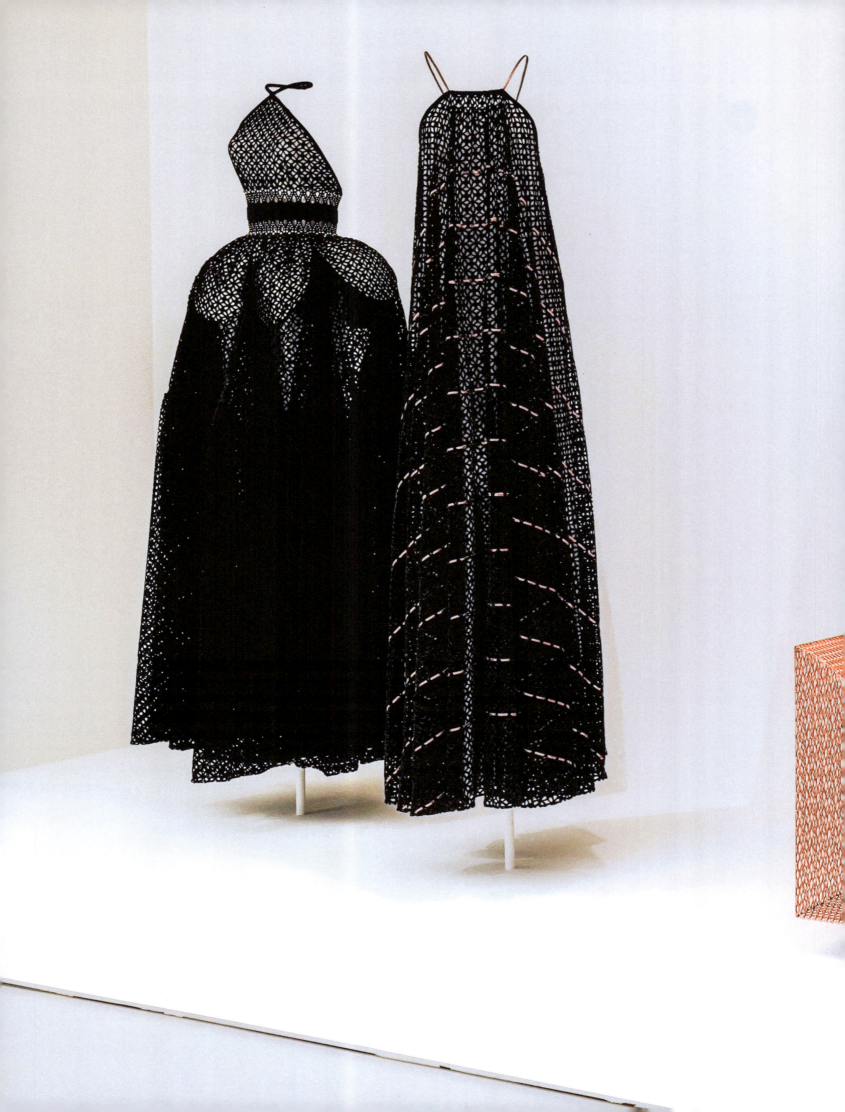

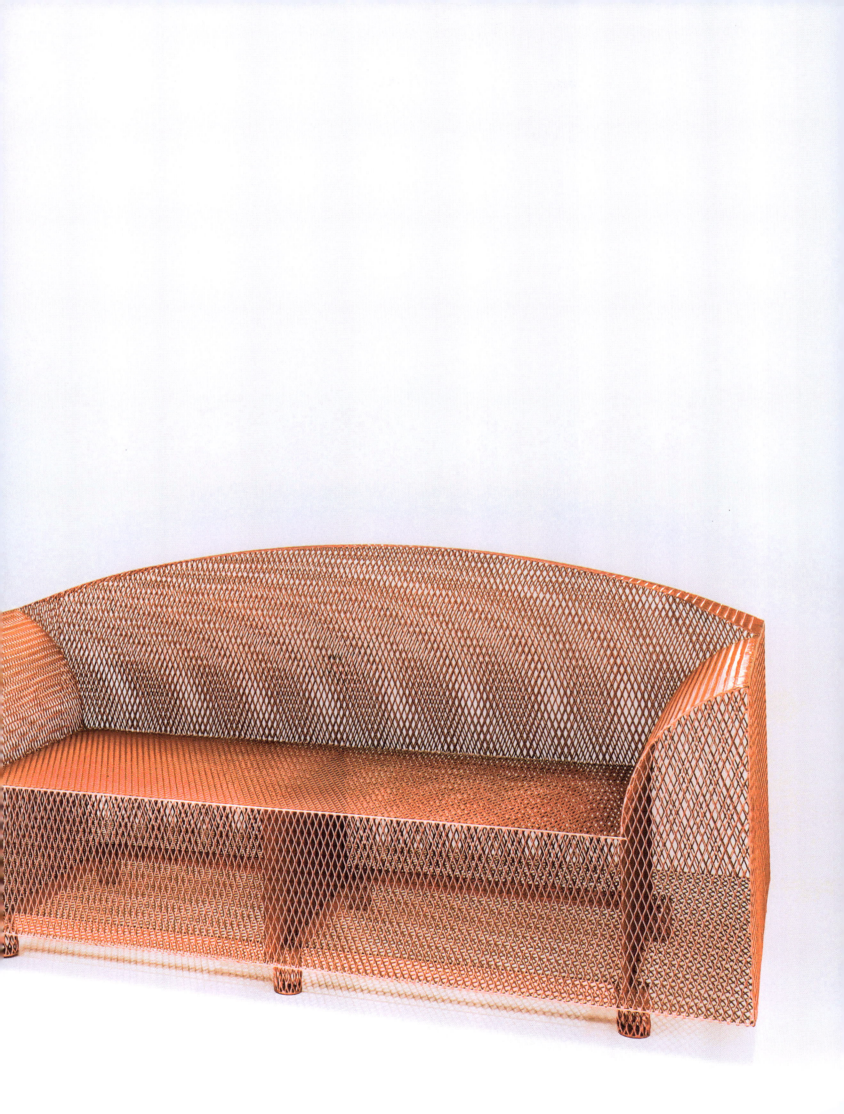

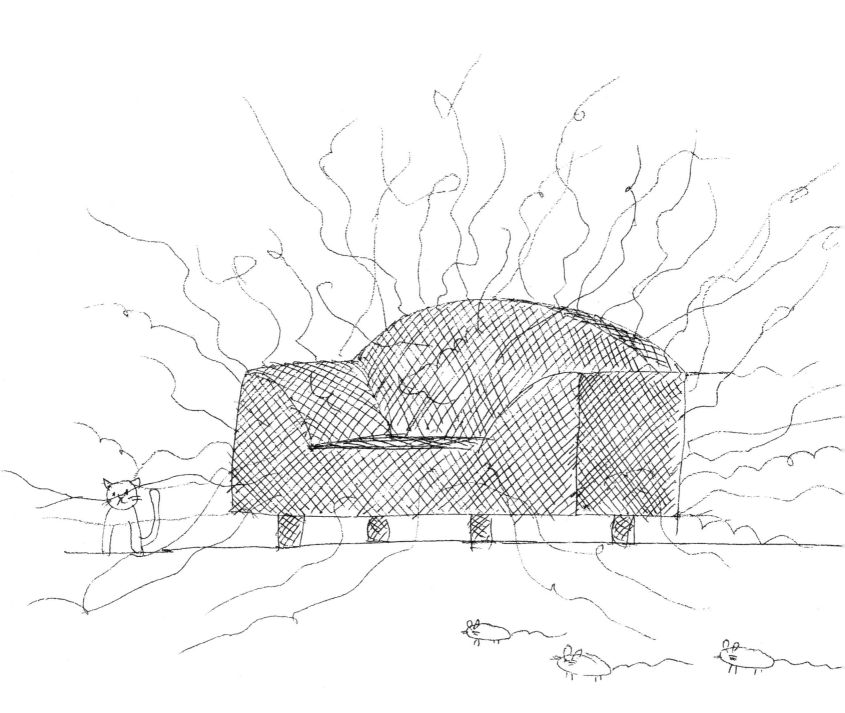

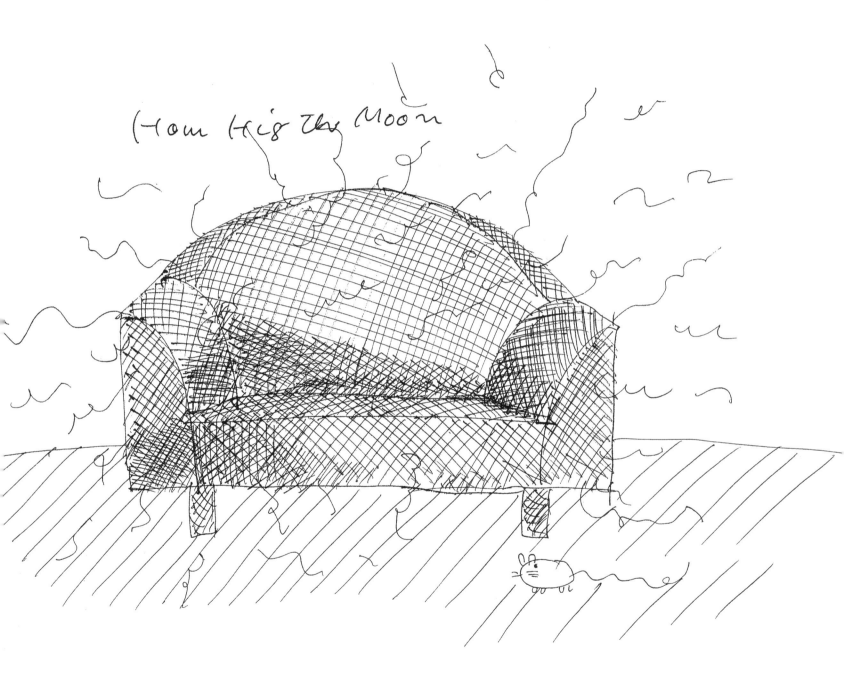

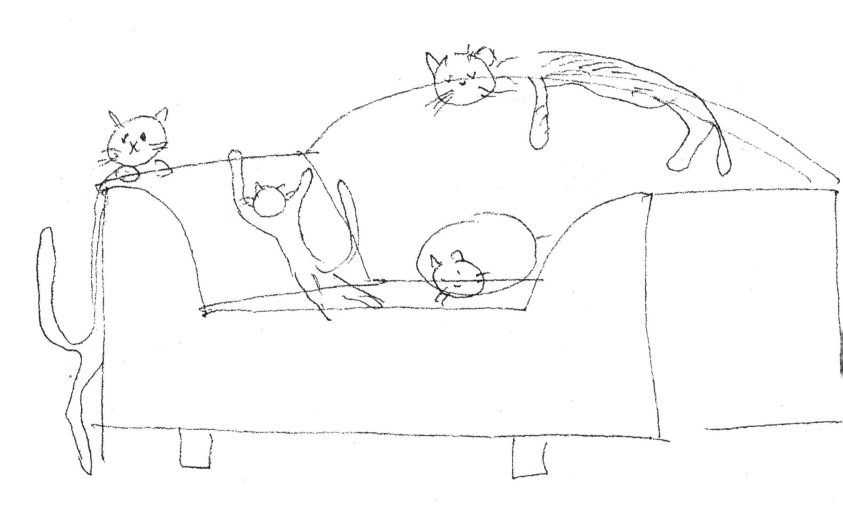

AZZEDINE ALAÏA
By Barbara Radice

Dear Azzedine, we met briefly and saw each other I think in your studio in Paris, together with Ettore and Carla and perhaps in the gallery together with Ernest Mourmans.

I remember your soft, gentle voice, your huge hairy dog that I was afraid of and tried to avoid in every way, as well as your wonderful sci-fi (science fiction) clothes that I hardly dared touch, let alone wear! I also remember with great admiration your passion for cooking and in particular, I can't explain why, a dish that I liked very much to eat but also and above all to look at.

It was a wide shallow bowl or perhaps a plate (?) who knows? Full of quinoa (which I tried for the first time in my life in your kitchen), topped with some very well-chosen aromatic herbs, perhaps French (or Tunisian?) a few green peas and wonder of wonders, bits of a delicious tender boiled carrot cut very small, the same size as the peas.

It was precisely the cut of the carrot that astounded me and made me realise how the special flavour and absolute splendour of that simple and colourful dish depended perhaps on that masterful cut that gave the carrots a special delicate and cheerful flavour next to the peas and quinoa.

Damn Azzedine, where did you go?

I always wanted to ask for instructions on how to reproduce that magical dish!

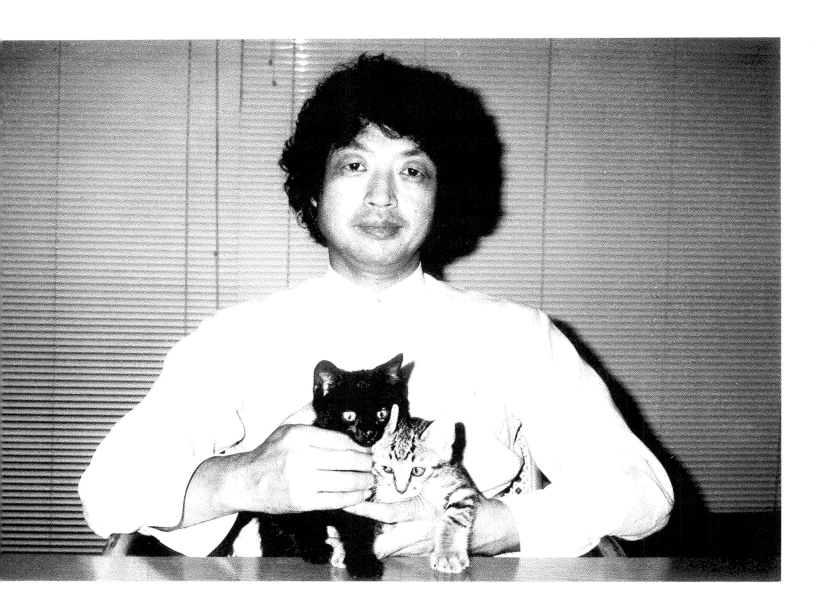

"I think it's speed that is the making—or the undoing—of today's Japanese design… There's no essentialism, and different phenomena have been transformed because of that speed, that acceleration (…).
I feel that it's time to slow down a little and engage more in contemplation".
Shiro Kuramata

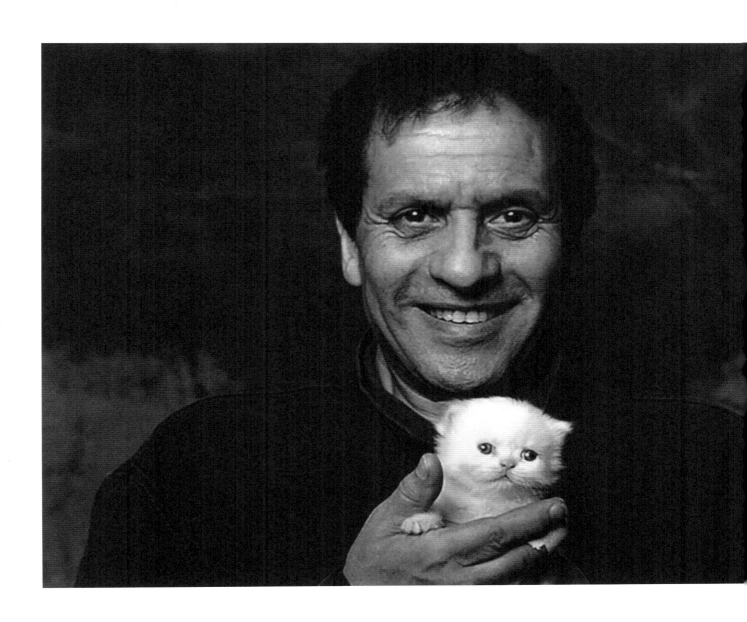

"The present fashion system is too hard, there are too many collections. The designers have no time to think. Schedules are too crazy".
Azzedine Alaïa

"I draw just to keep a record of my work. I sketch out a shape onto tracing paper,
I cut it out and I pin it onto a piece of paper.
Then I start working on a tailor's dummy, but I need a real person for the fitting.
Because a woman moves, her body moves, and I need to see
how the fabric behaves on her".
Azzedine Alaïa

"I draw everything in my head. The images always come to me first.
When you draw, you tend to focus on peripheral aspects (…)
and before you know it, that can end up replacing more essential questions
that need to be considered".
Shiro Kuramata

WHEN AZZEDINE ENCOUNTERED SHIRO
By Carla Sozzani

Trained in sculpture as he was, Azzedine Alaïa was always sensitive to the quality of the design of objects around him, and the rooms in which they lived; and his approach in building his design collection reflects the same attention to craftsmanship, form, and innovation that characterized his own designs in fashion. He preferred clean lines, modernist influences, and pieces that were both functional and aesthetically strong while maintaining an agility and lightness in how they impacted the environment.

His appreciation for design was all encompassing; seeing no boundary between fashion and other forms of design, his spaces were known for their precise aesthetic, where fashion, art, and furniture were seamlessly integrated, blending fashion and design in innovative ways. Azzedine Alaïa's relationship with furniture design was to become an extension of his broader design sensibilities. His relationship with furniture design is today a fascinating aspect of his creative legacy.

Azzedine Alaïa's first "encounter" with Shiro Kuramata was in Milano, at my gallery. In 2003, I had finally realized one of my dreams of mounting an exhibition of one of the most important designers of the XXth century. Ettore Sottsass, whose influence is now seen as hugely influential to the mid century design movement, had graciously agreed to write the text for the show.

Ettore took the title from a letter written by Shiro to Barbara Radice and which was to name the exhibition, "It's always snowing when I write to you". Ettore Sottsass and Shiro Kuramata had been working together since the inception of Memphis in the early 1980's. Both used to define their relationship as magical. When Kuramata received a letter from Sottsass asking him to join Memphis he was so elated that he said "I have received a love letter from Sottsass".

Kuramata's work totally seduced Azzedine. For him, Kuramata's design sense transcended the ordinary. He saw in them a purity, a physical poetry that worked to create the perfect balance between strength and delicacy.

For Azzedine, this was a reflection of the harmony that he himself aspired to achieve in his own work.

He wanted to know more. To pierce the veil and find the essence of the process that could make such works. So while not speaking English , Azzedine immediately created a strong link with Mieko Kuramata, Shiro's wife. A "celestial wife", Ettore Sottsass would call her - and their beloved little girl. A bond of love of beauty was born between them.

A strong friendship was also born with the art critic Barbara Radice, one of the founding members of the Memphis Group and Sottsass's wife.

The Memphis Group in which Shiro Kuramata had participated in the 80s was legendary. It had been one of the first truly global movements that heavily influenced twentieth century design and brought international attention to the city of Milano. It became important to Azzedine who a few years later would be the first to host in Paris at his gallery the same "Memphis Blues" show of the Memphis designers from Milano that he had admired in my gallery.

Immediately Azzedine decided to bring the Kuramata exhibition to his newly opened gallery in Paris, and began to buy pieces of Kuramata with the consistency that he always showed when collecting artists he admired. Mieko Kuramata participated in the curation of the exhibition by lending rare and rarely seen pieces. It was the first design exhibition that Azzedine hosted at his new gallery in Paris, and Kuramata's body of work remains today the largest of the holdings in the design collection of the Alaïa Foundation.

Twenty years later, this exhibition highlights the parallel between Kuramata's and Alaïa's work. It is not surprising to see that Azzedine Alaïa and Shiro Kuramata, though from different disciplines, shared a deep connection in their approach to design. Sadly, they never had the opportunity to meet, but the many parallel lines, particularly in terms of innovation, mastery of form, and a quest for a pure and timeless aesthetic are here clearly revealed.

Alaïa is known for sculpting garments that accentuate the human form. His dresses were often described as architectural, shaping the body. He meticulously researched and worked with a variety of materials to create a sense of structure and fluidity simultaneously.

Kuramata approached his pieces with a similar sculptural mindset. His work often transcended traditional furniture design, blurring the lines between art and functionality. His pieces are celebrated for their innovative use of materials and their sculptural qualities, which make them feel like art objects as much as functional furniture.

Alaïa was a pioneer in using unconventional materials in fashion, such as stretch fabrics, leather, and metallic elements, pushing the boundaries of what could be considered couture. His mastery of these materials allowed him to create garments that were not only beautiful but also technically advanced, offering both form and function. Kuramata was known for his groundbreaking use of materials like acrylic, glass, and aluminium. He introduced a sense of transparency and lightness in his designs, creating a floating, ethereal effect. Kuramata's work challenged the traditional

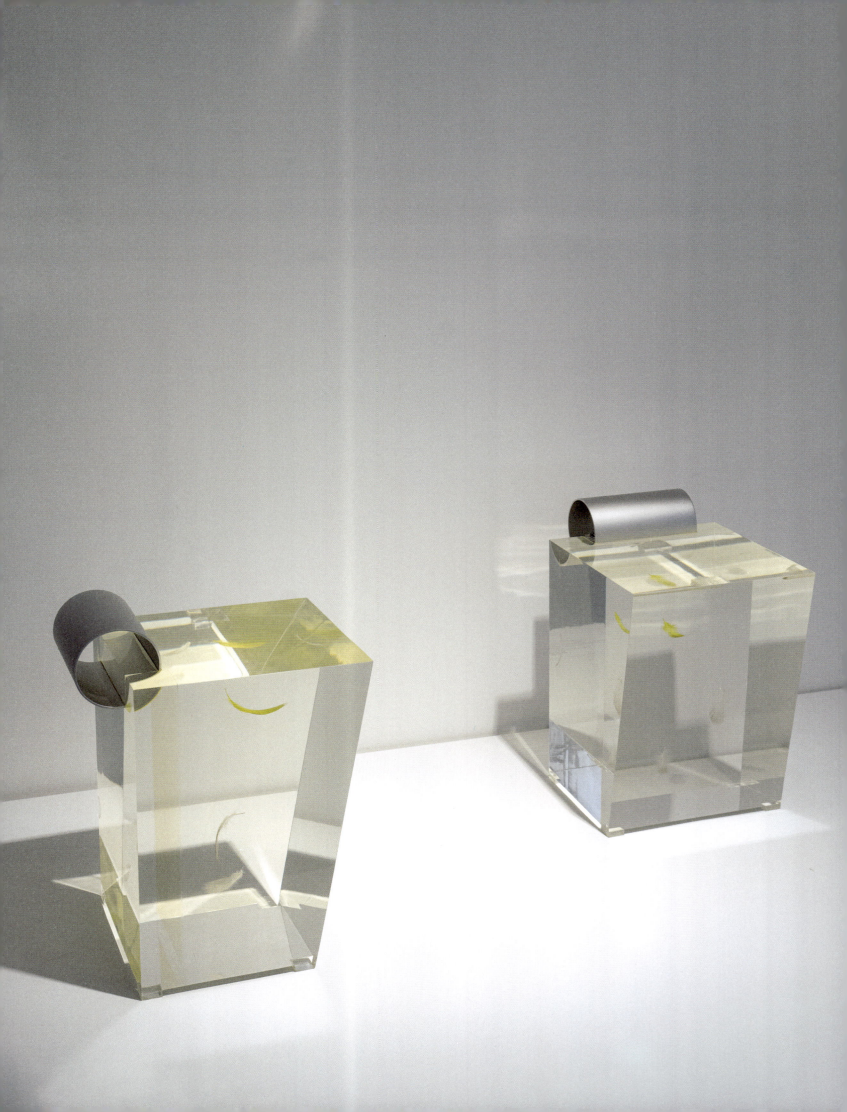

perceptions of materiality in furniture design, much as Alaïa did in fashion.

Alaïa's designs were often characterized by their precise yet sensual aesthetic. He avoided unnecessary embellishments, focusing instead on the purity of form and the beauty of the materials he used. His clothes were impeccably constructed, with high precision.

Kuramata's designs also embraced clean lines and simple forms that exuded elegance. His work was often described as avant-garde yet minimalist, balancing between being starkly modern and subtly poetic. He stripped away the superfluous, allowing the essence of the material and form to speak for itself.

Alaïa's work, timeless, is said to be "beyond fashion". His designs, designs, relevant and admired today, are not tied to any specific era or trend. His influence continues to be felt in the fashion industry, particularly in how designers approach the female form and the construction of garments.

Similarly, Kuramata's designs reflect this same timeless quality. His furniture pieces are icons that continue to influence designers today who celebrate both their innovative approach and enduring appeal.

Azzedine Alaïa and Shiro Kuramata, though from different disciplines and different cultures, shared a profound respect and understanding of design as an art form. They created pieces that felt like dreams, yet still were grounded in functionality. Alive with emotion and intellect, Kuramata's and Alaia's works are poetic expressions of their unique visions; timeless and full of soul, their creations are an extension of their passion, level of precision in executions, and unwavering dedication to beauty.

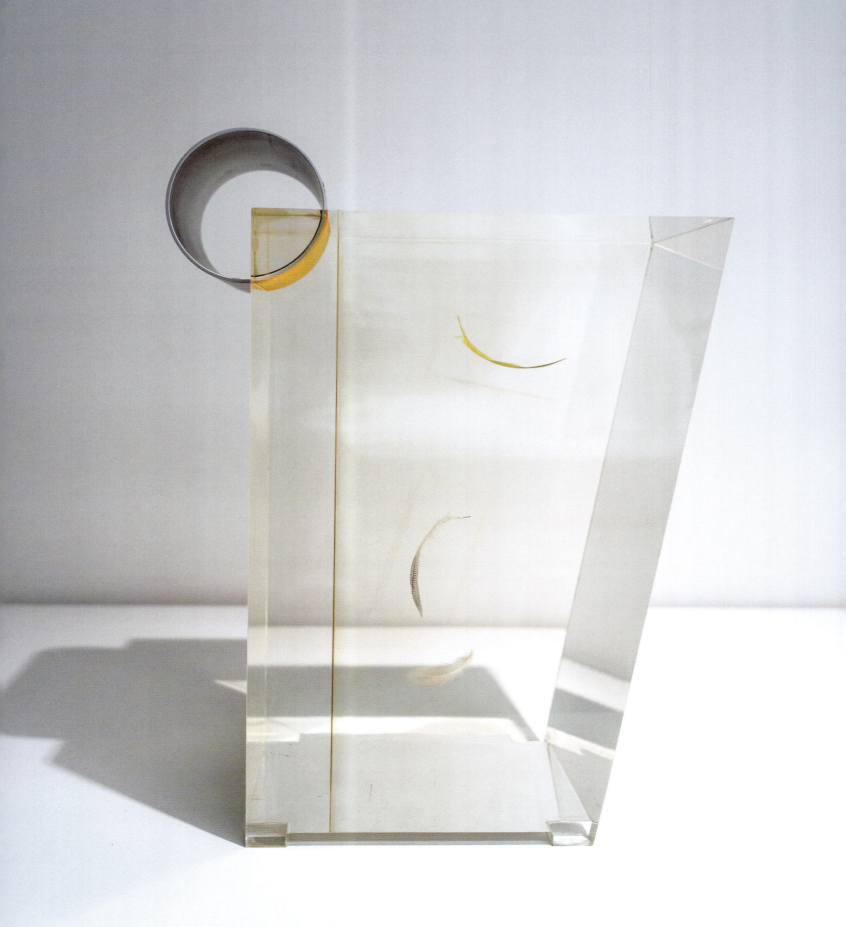

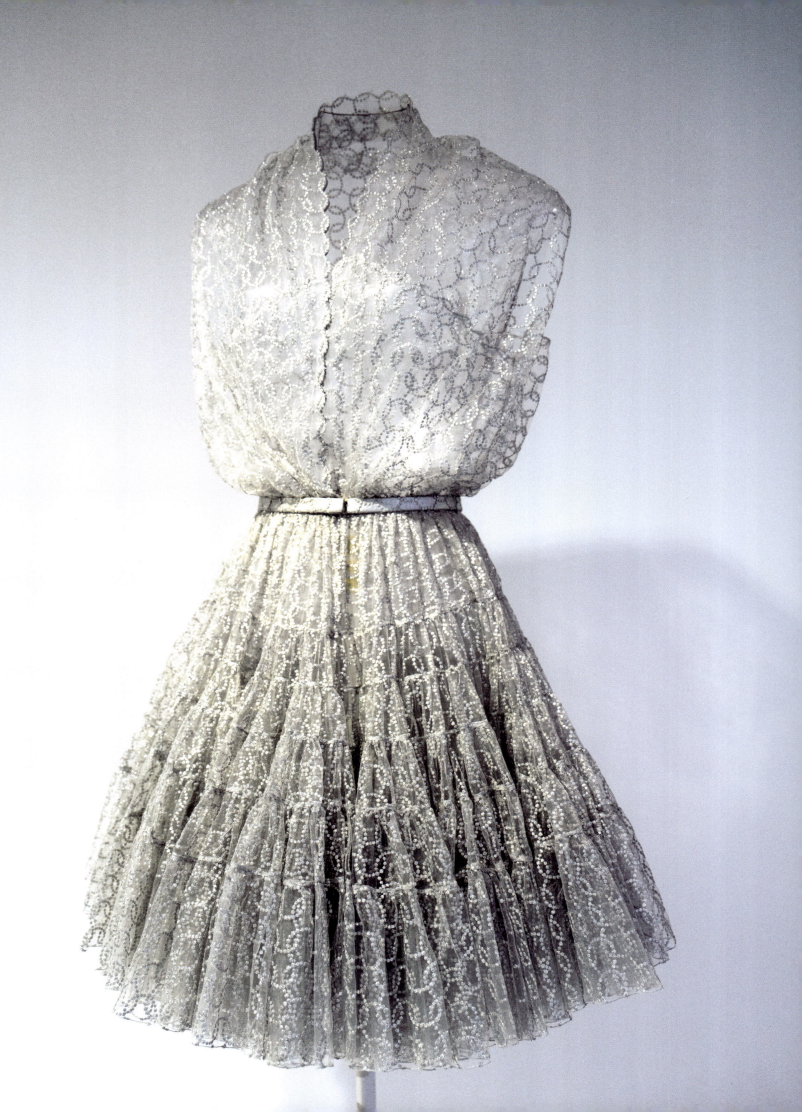

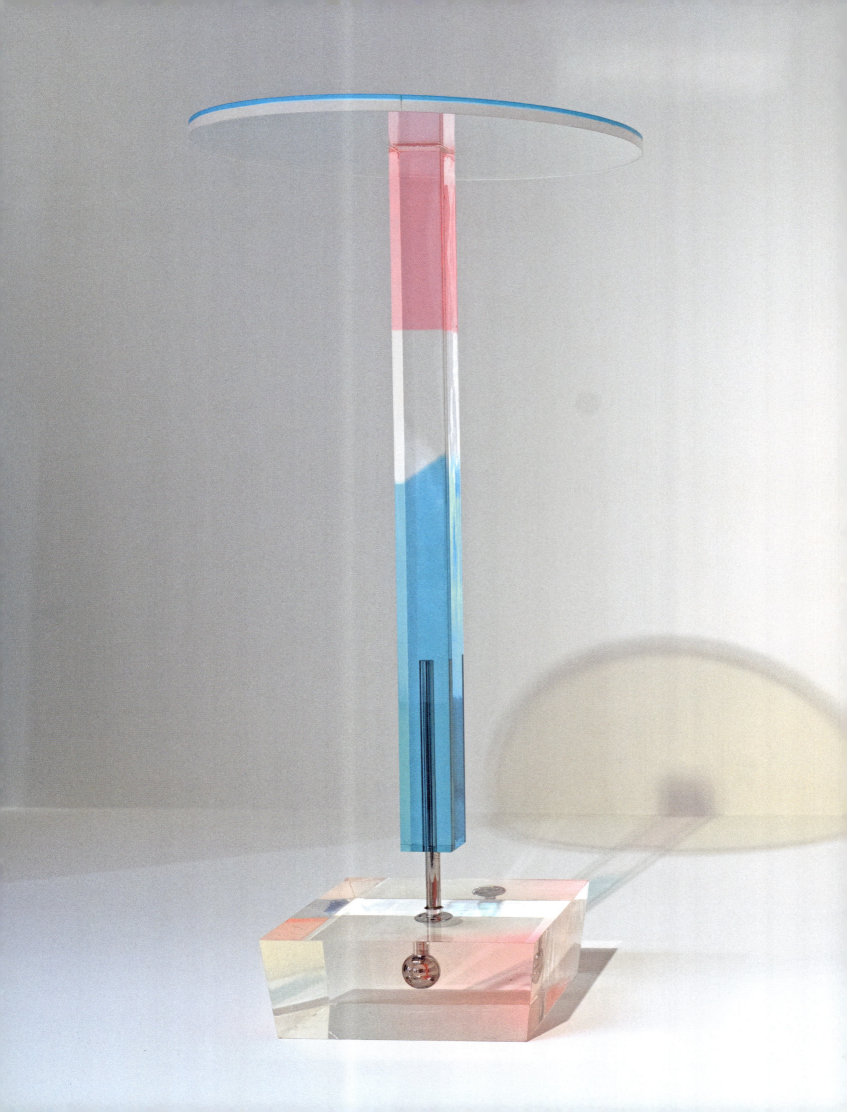

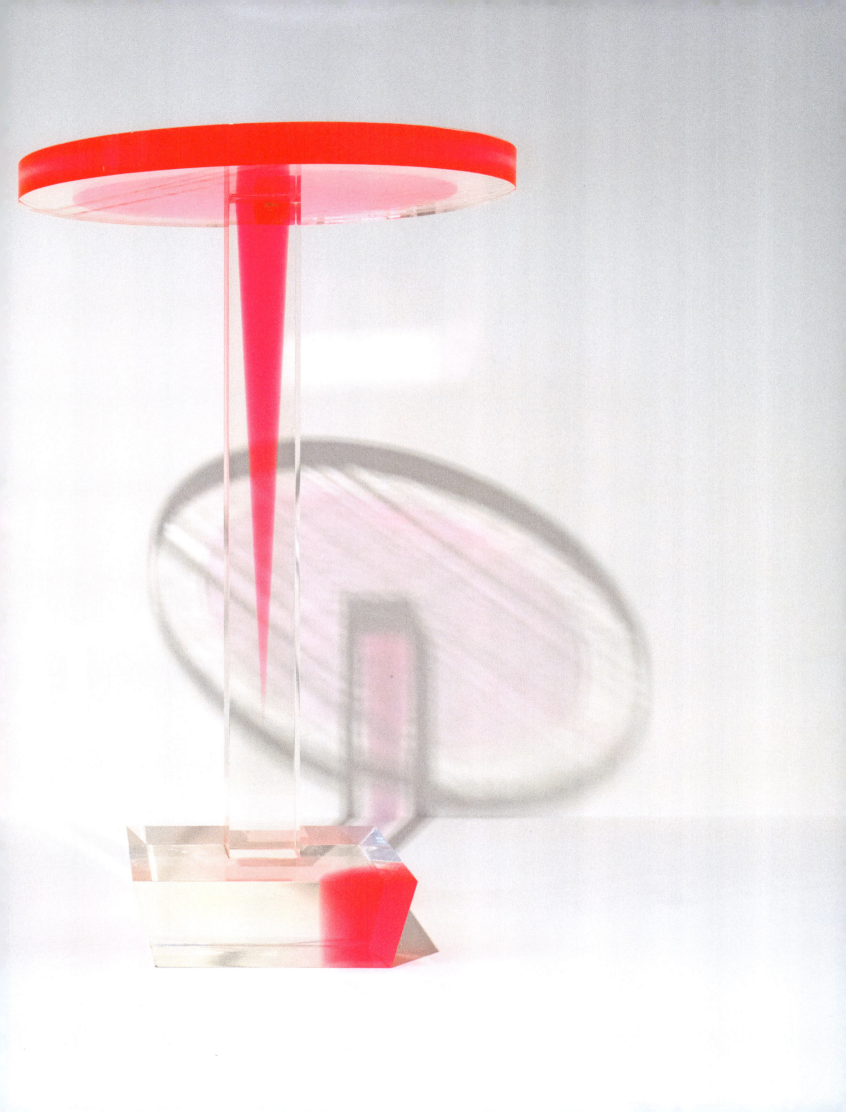

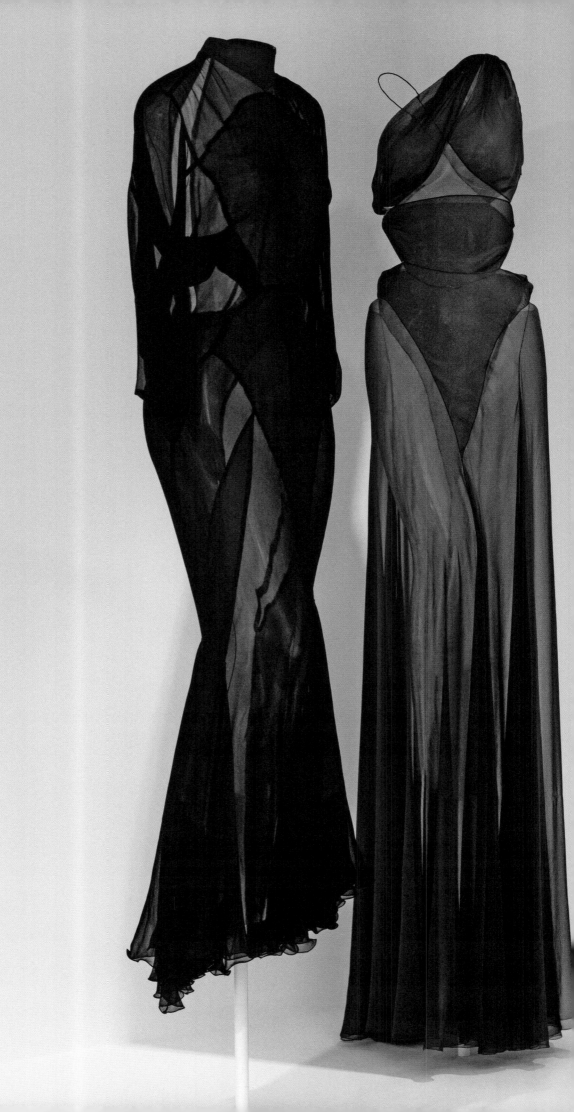

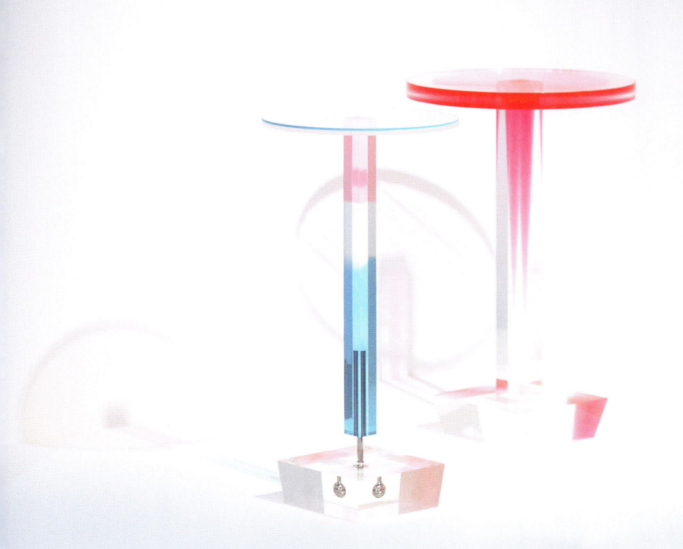

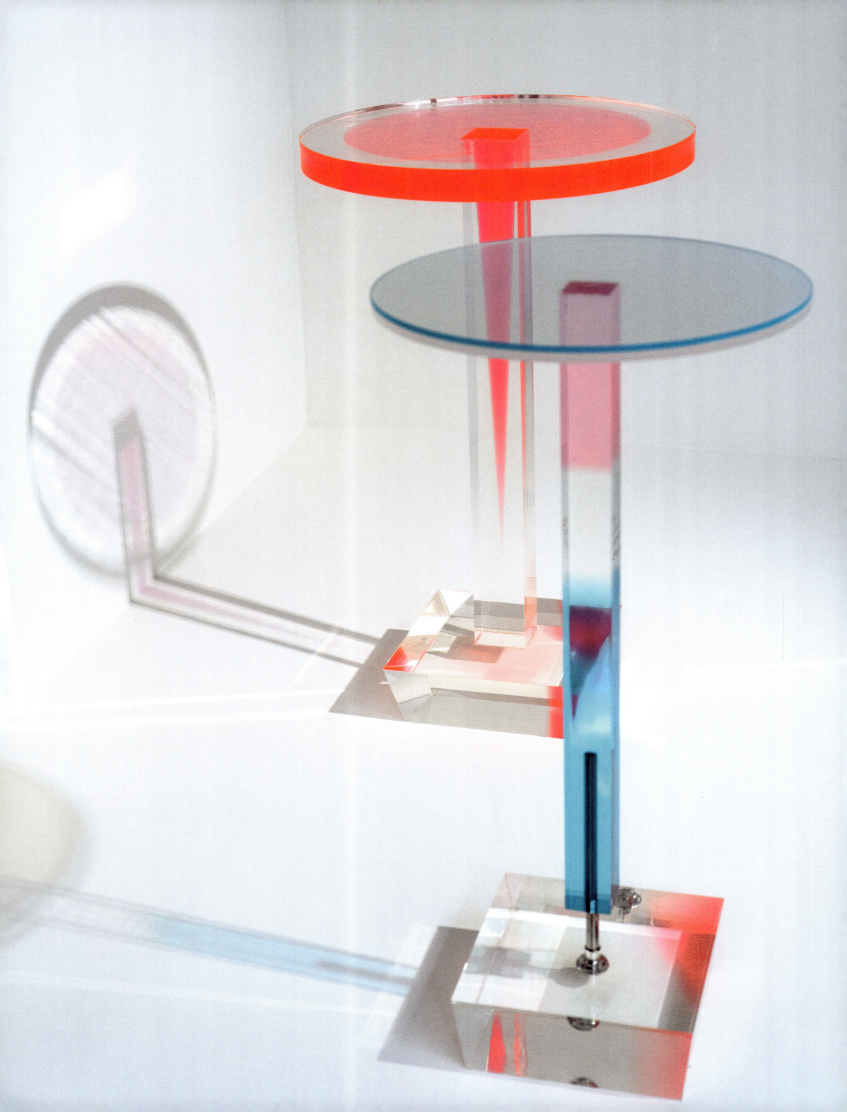

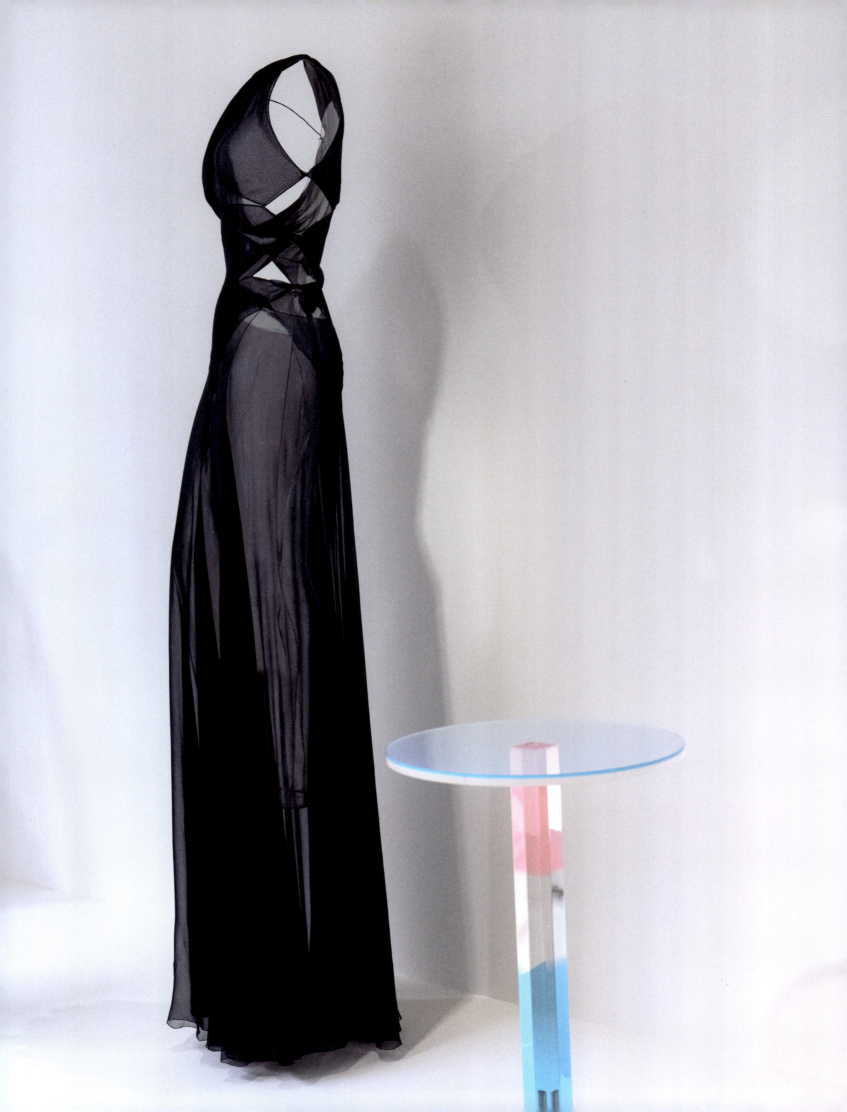

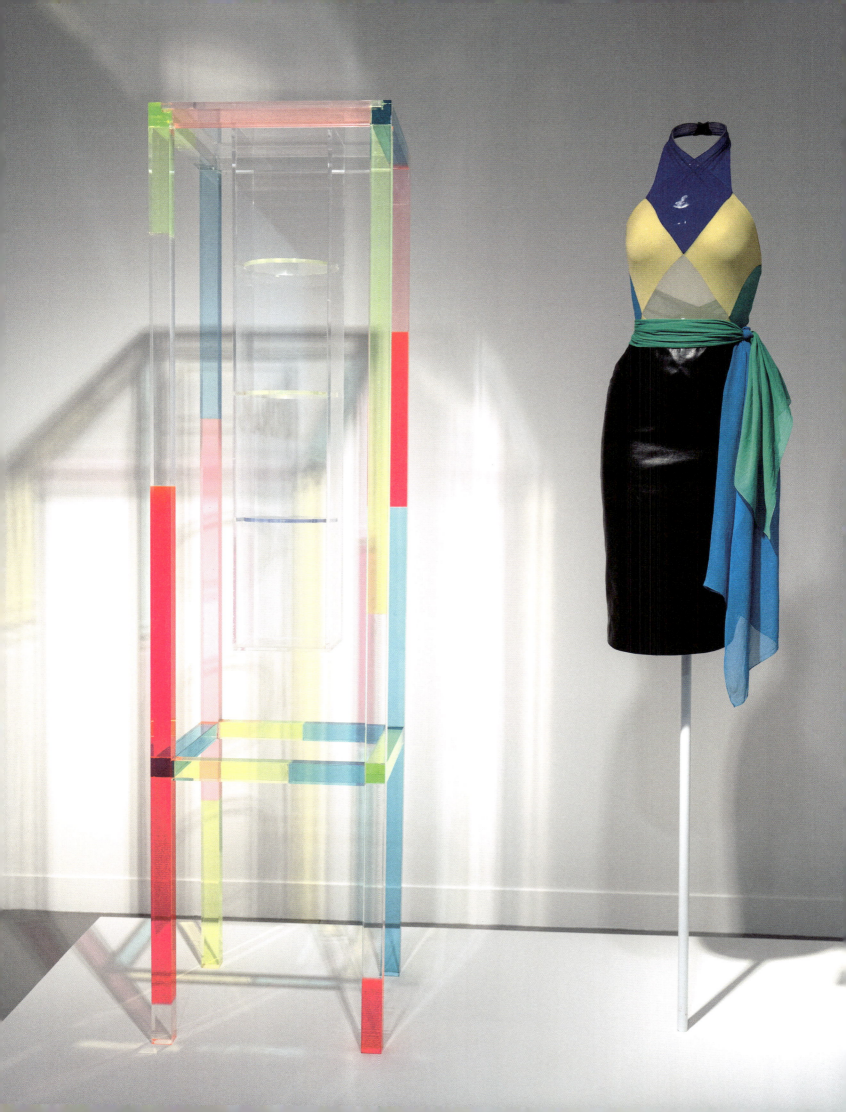

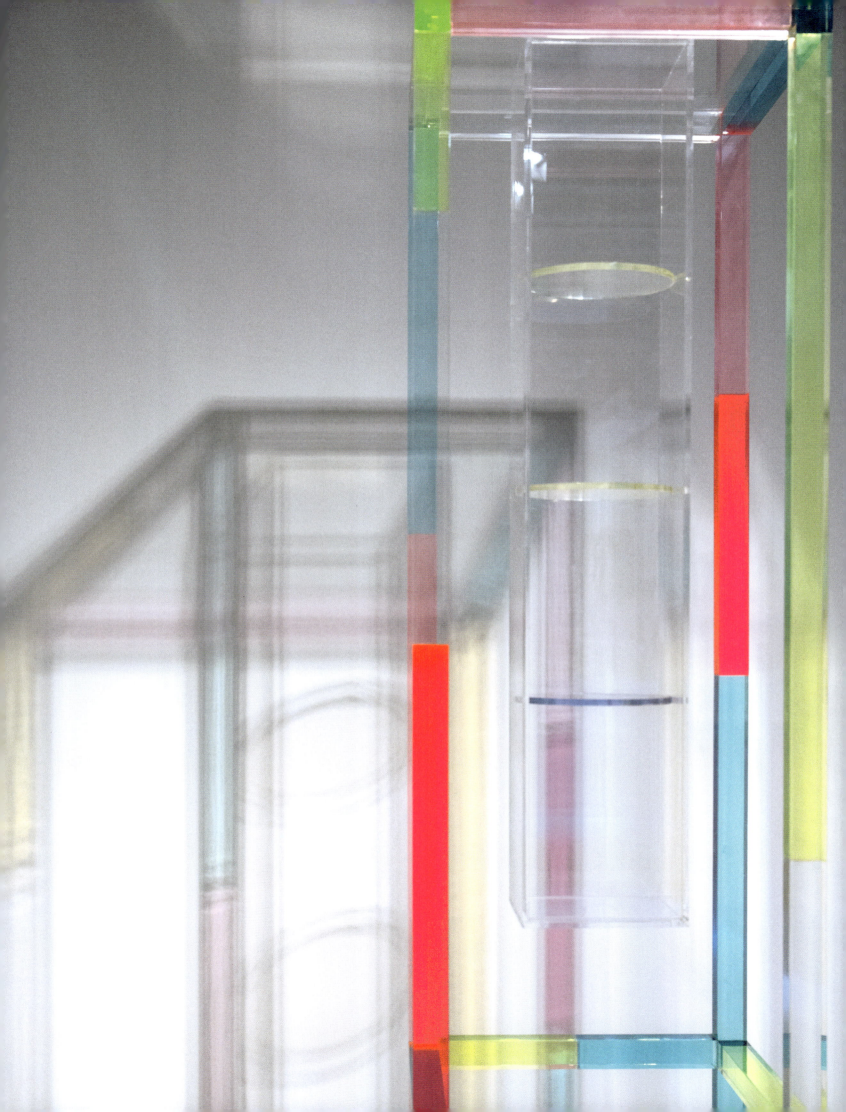

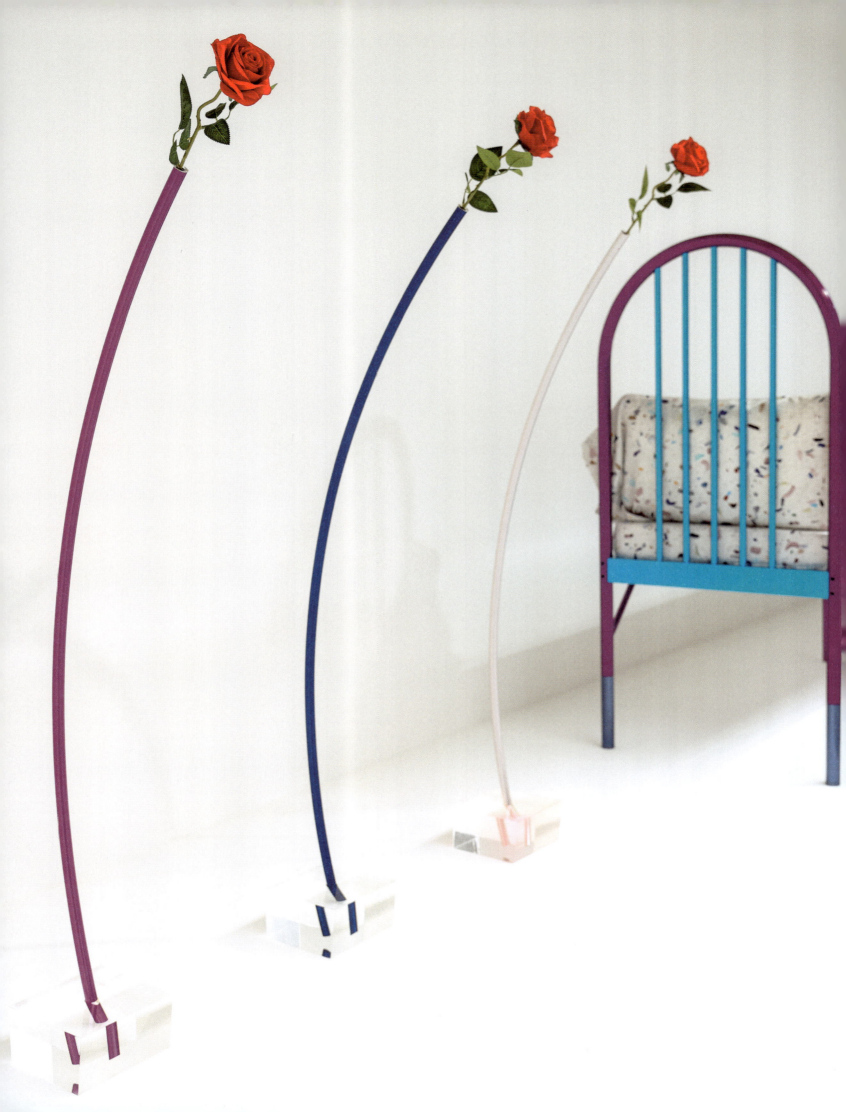

THE SIGN OF THE ROSE
By Riichi Miyake

When I first saw Shiro Kuramata's *Laputa*, it was unaccaountably an Anatolian Sufi sanctuary that sprang to mind...

Like something out of *Gulliver's Travels*, the oversized 4,2 metres bed *Laputa* was itself created for a dream.

Thus Kuramata, in his perpetual search for new worlds in interior space, sketched precisely what he saw in his mind's eye.

Here beside the bed, as if to watch the dramas to unfold thereupon, we see a slightly tilted row of flowers, above which spreads a heaven of shooting stars.

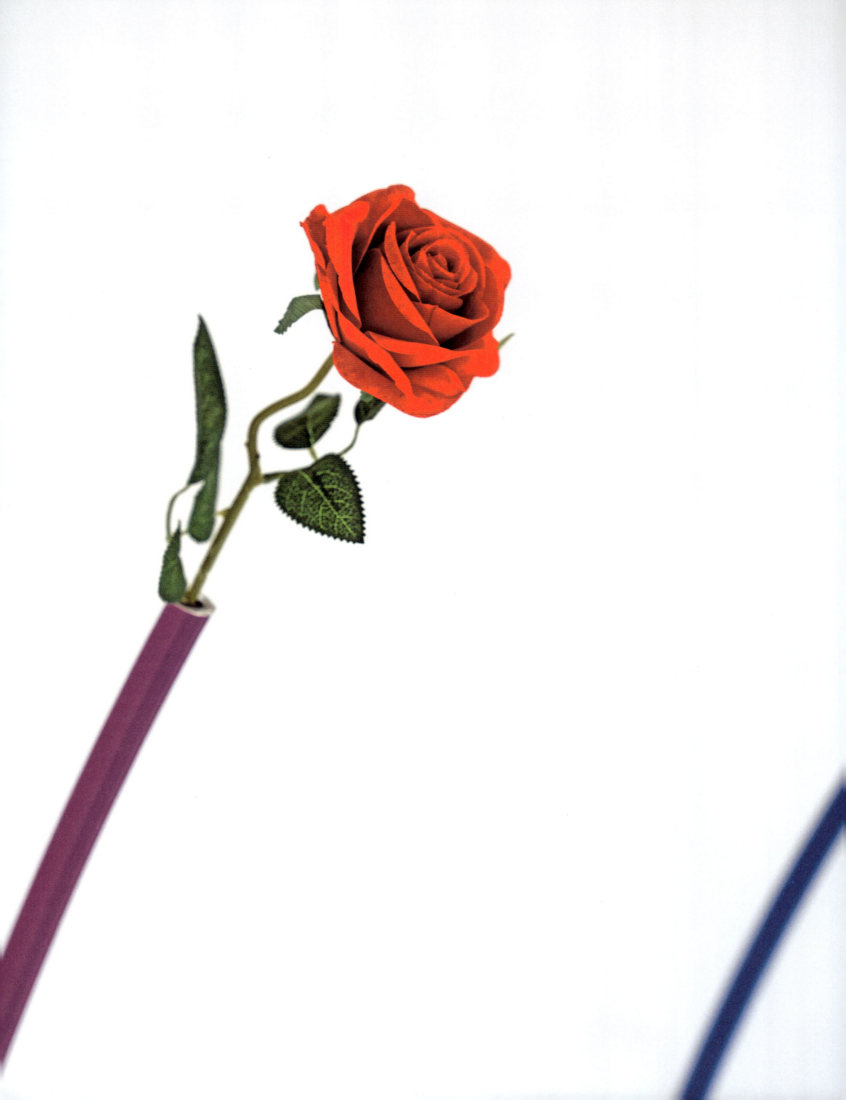

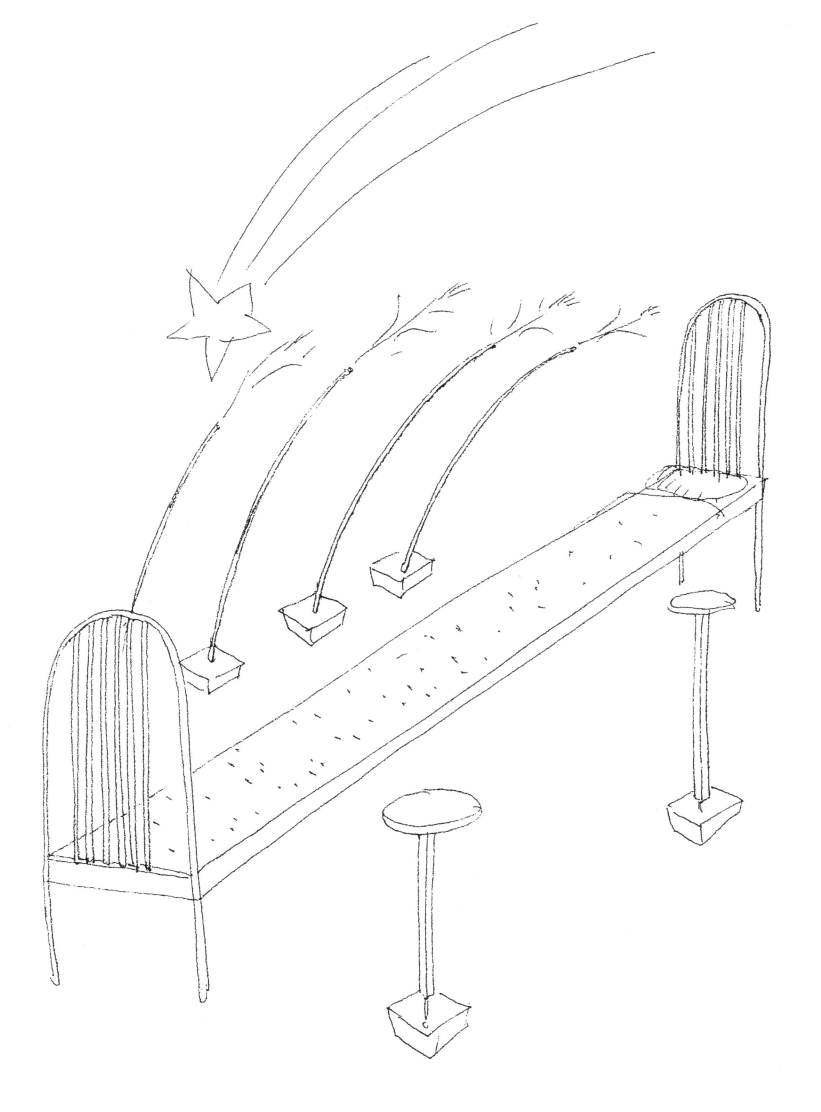

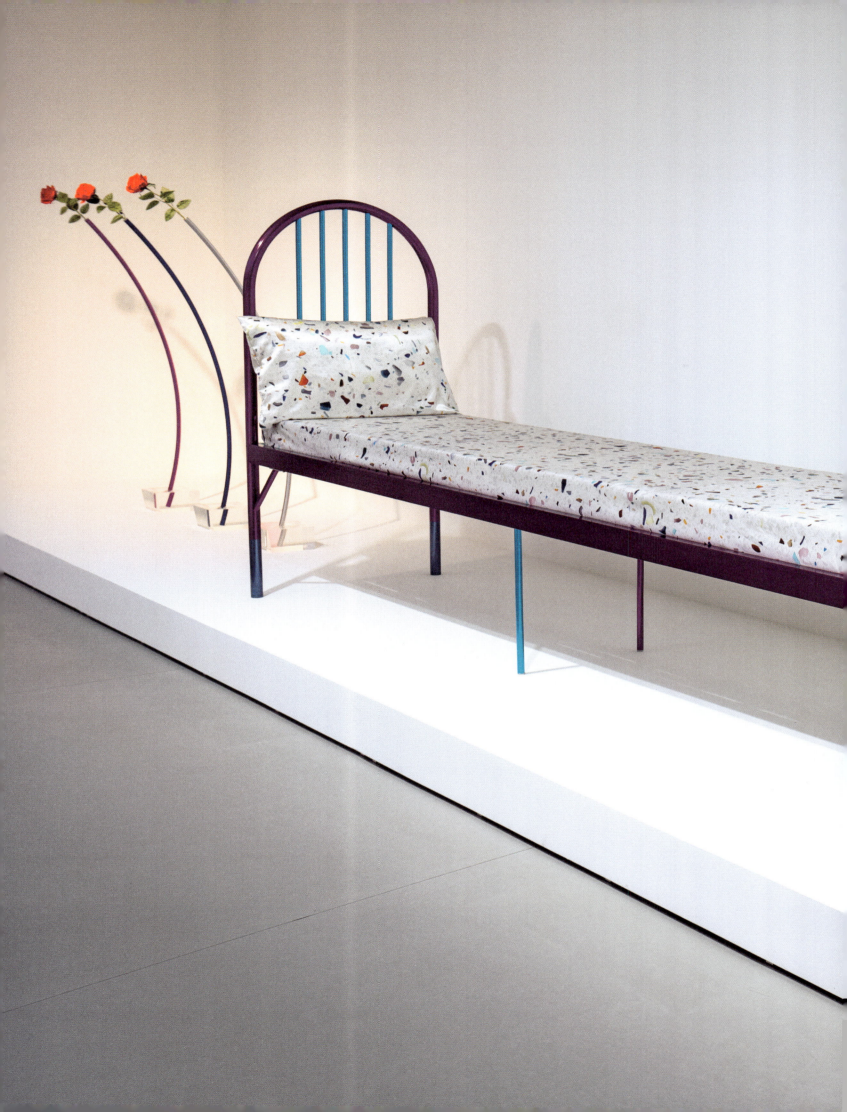

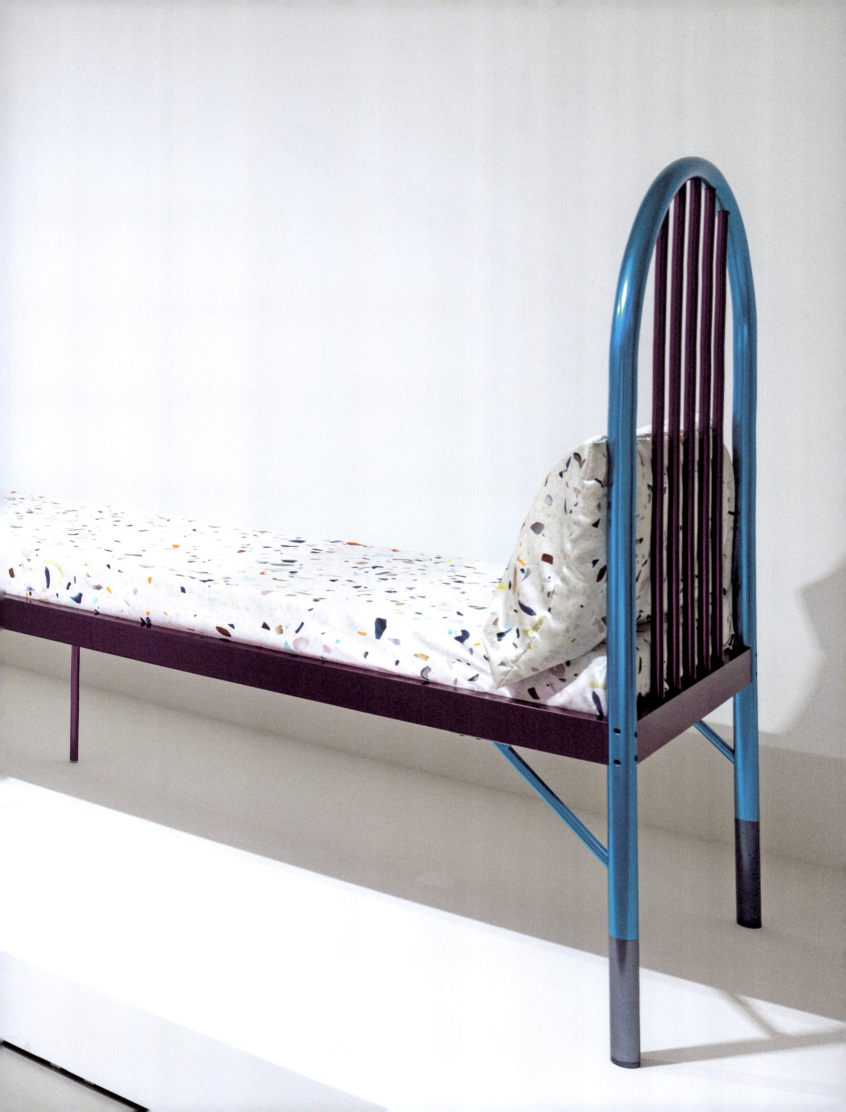

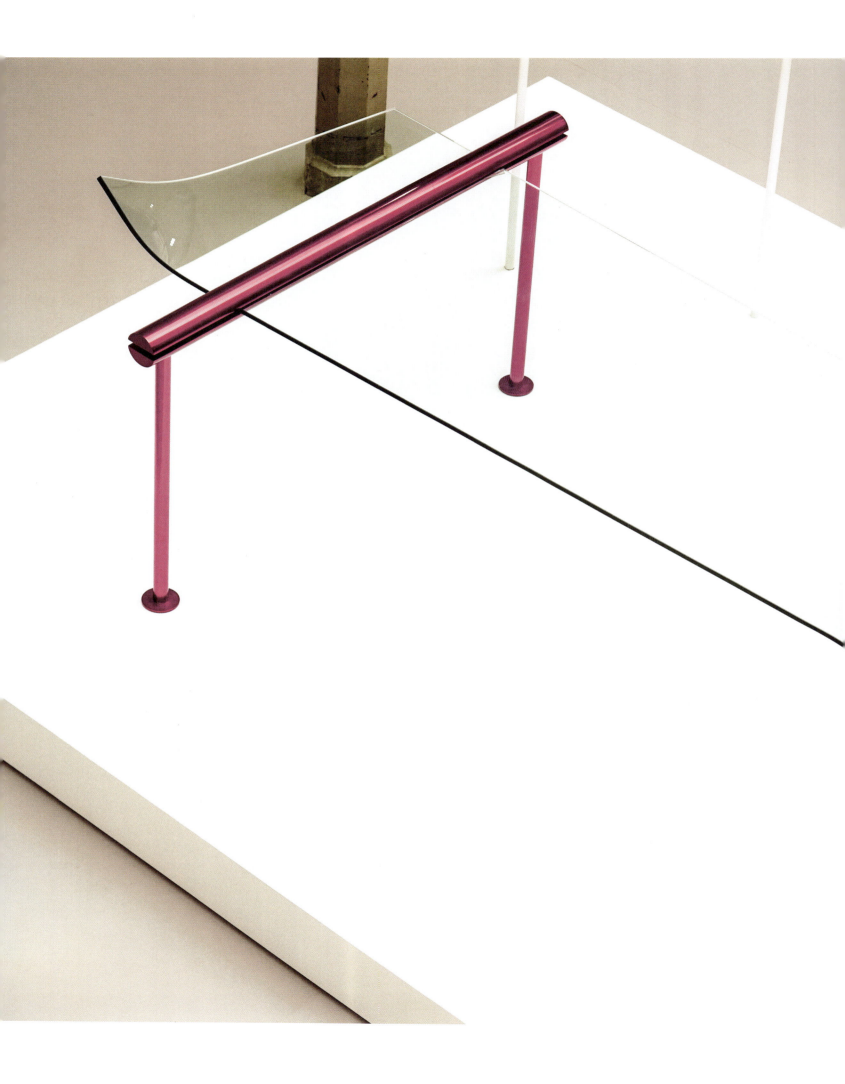

"Designing is an act of transience.
In this sense, design is very similar to Tokyo.
There is no concrete or eternal thing there".
Shiro Kuramata

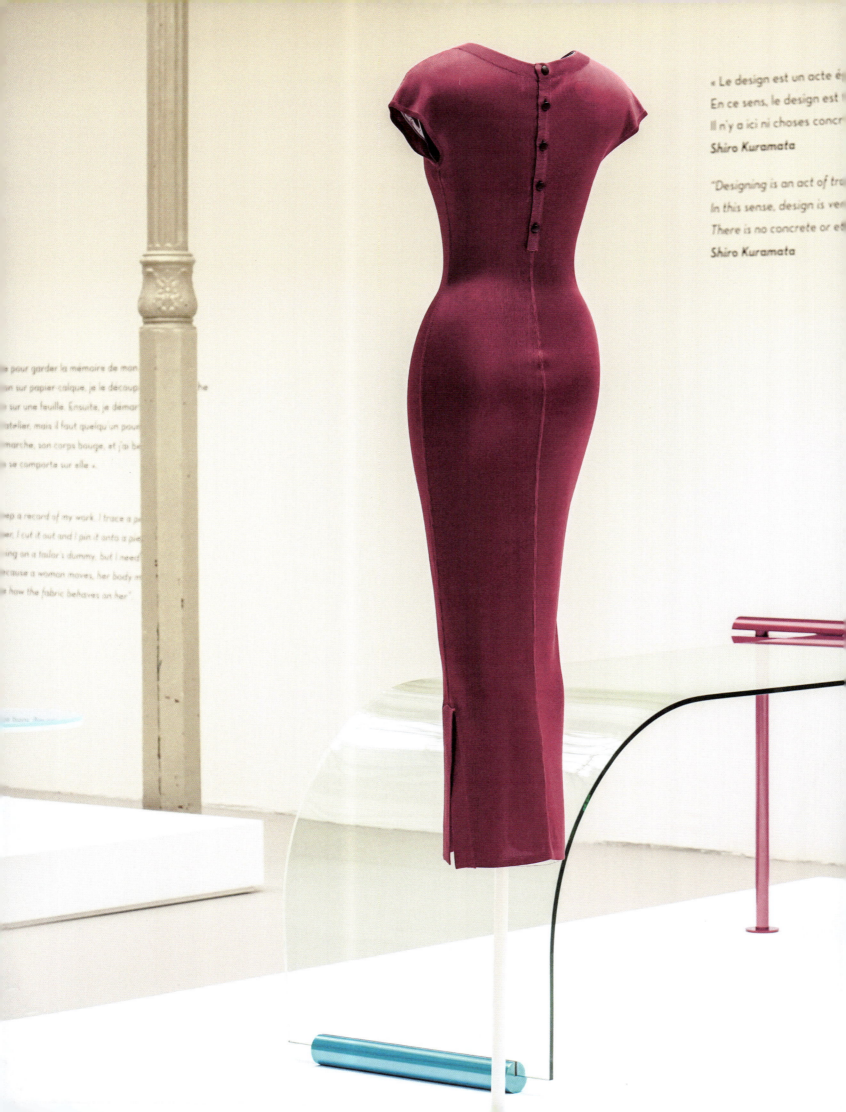

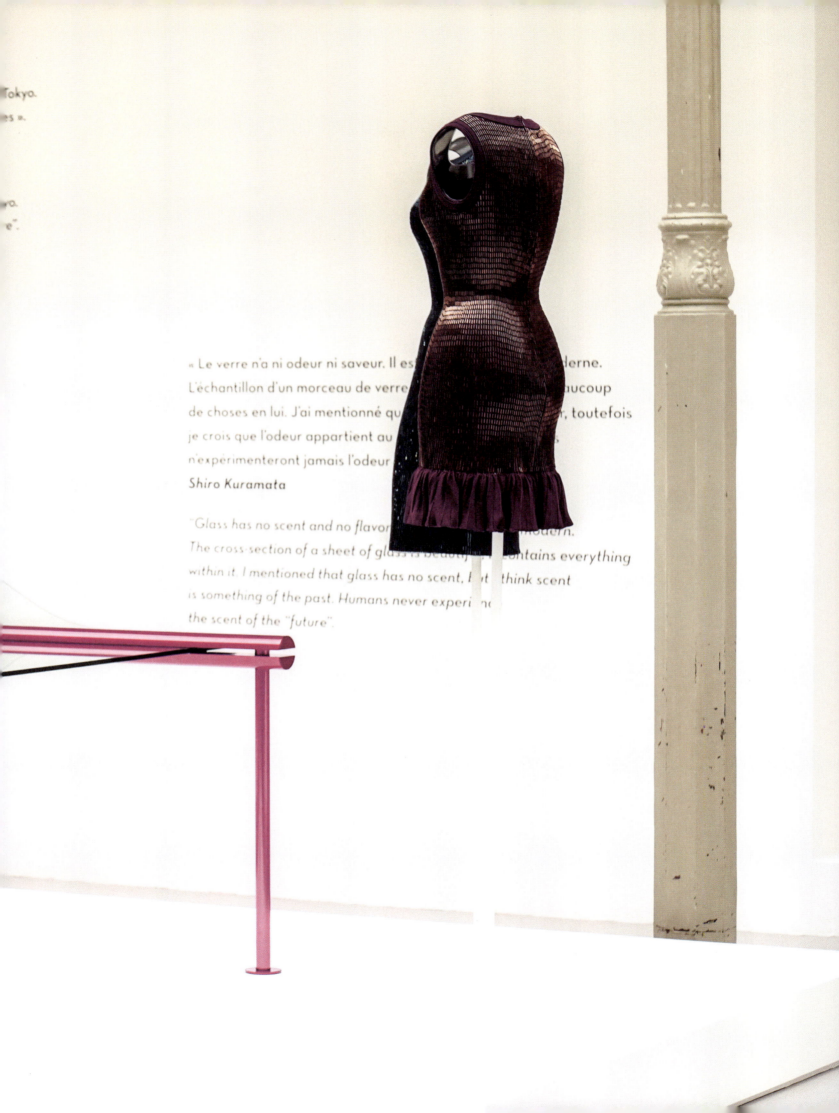

« Le verre n'a ni odeur ni saveur. Il est ... derne. L'échantillon d'un morceau de verre ... aucoup de choses en lui. J'ai mentionné qu... toutefois je crois que l'odeur appartient au ... n'expérimenteront jamais l'odeur ...
Shiro Kuramata

"Glass has no scent and no flavor... ...dern. The cross-section of a sheet of glass is beauty... contains everything within it. I mentioned that glass has no scent, ... think scent is something of the past. Humans never experi... the scent of the "future".

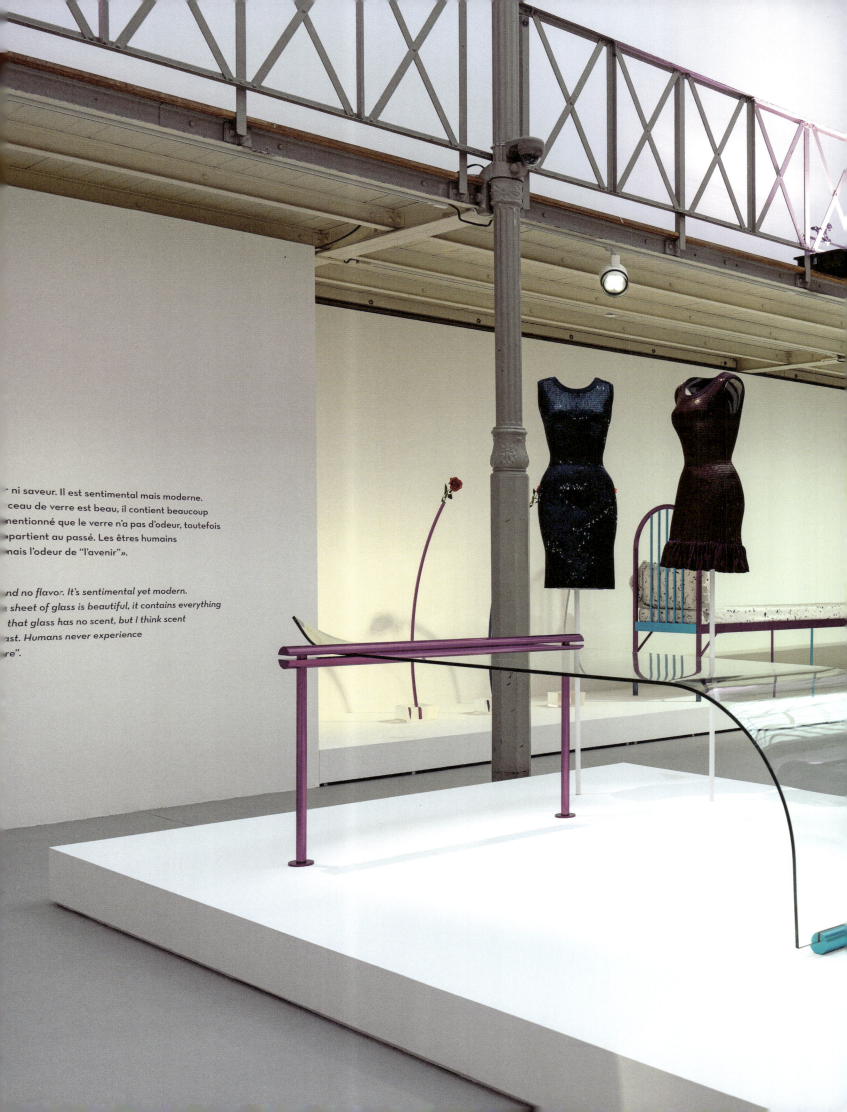

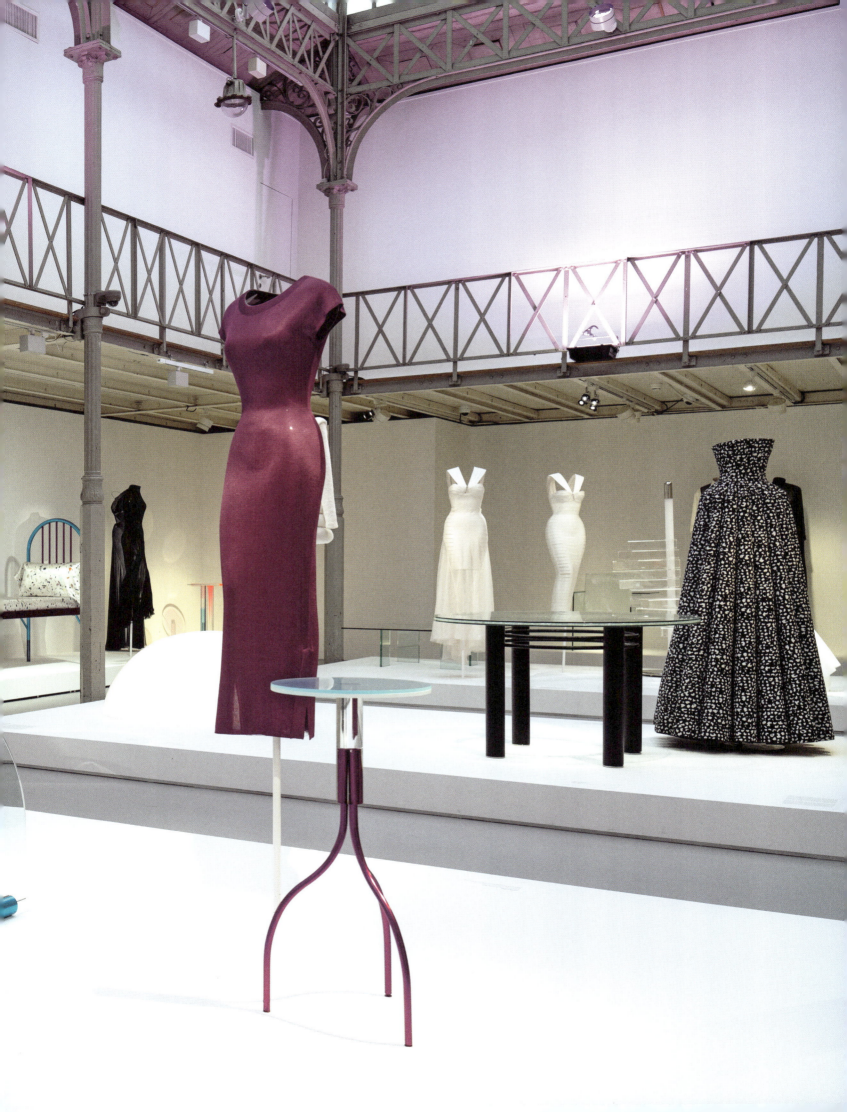

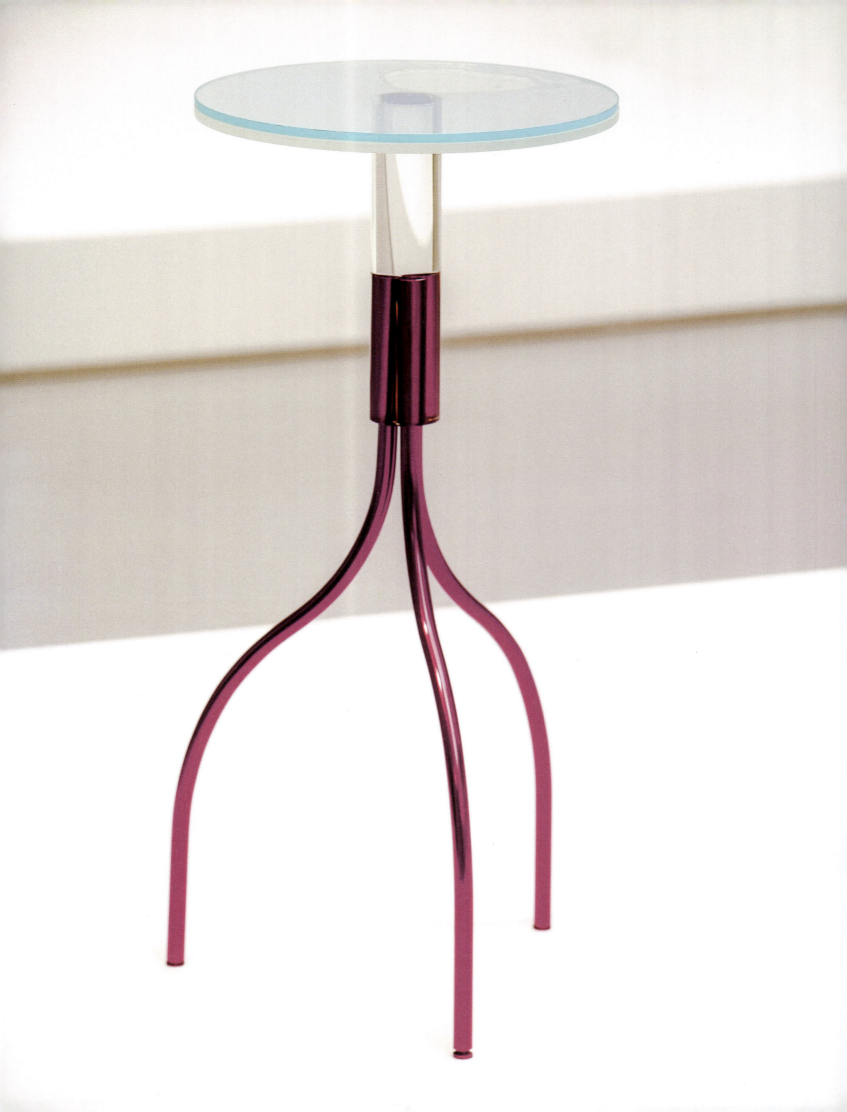

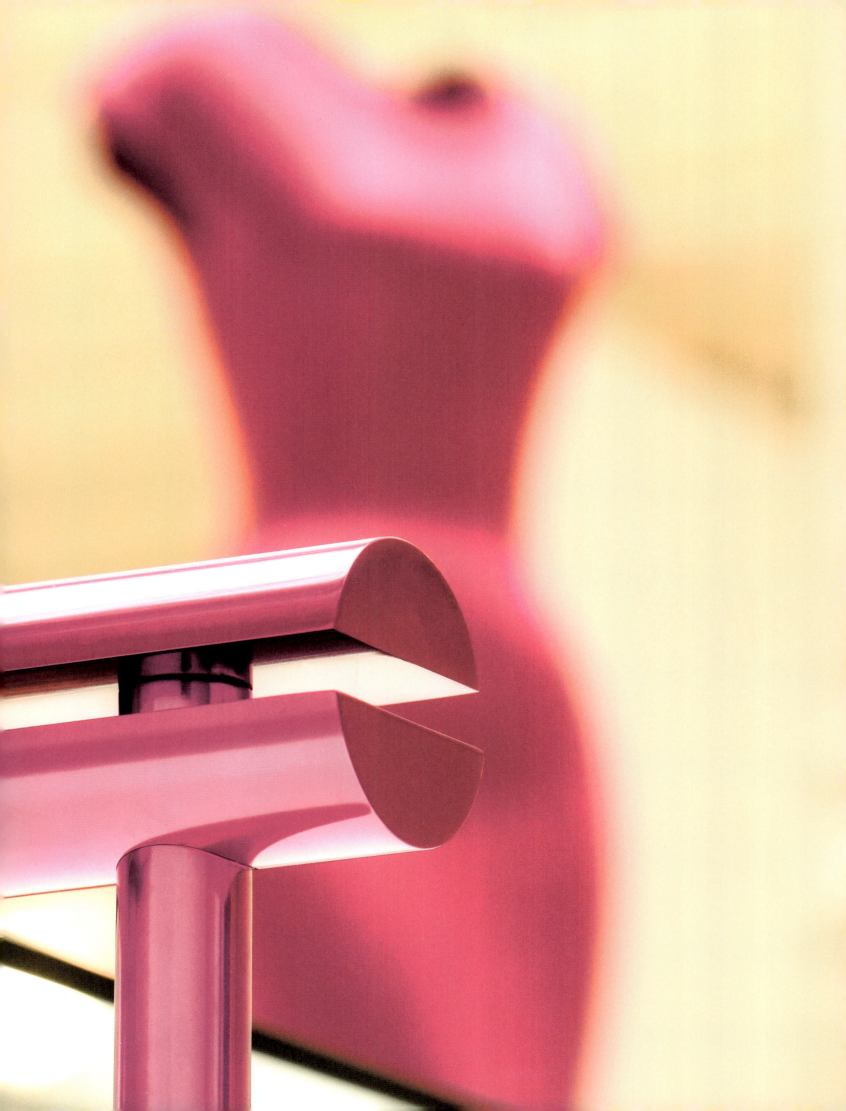

BOOK CAPTIONS

Shiro Kuramata
"Revolving cabinet"
Column furniture, 1970
Red acrylic plastic, twenty mobile trays around a central axis.
Azzedine Alaïa
Ready-to-wear Spring/Summer 1986
Top and skirt ensemble in red acetate knit, bandage skirt closed with laces at the side.
PH. SYLVIE DELPECH

Shiro Kuramata
"Cabinet de curiosité" 1989
Detail.
PH. SYLVIE DELPECH

Shiro Kuramata
"Glass Table", 1976
Detail.
PH. SYLVIE DELPECH

Azzedine Alaïa
Ready-to-wear Autumn/Winter 1991
Short dress in white viscose velvet and elastane knit with open-work seams, skirt with padded hem.
PH. STÉPHANE AÏT OUARAB

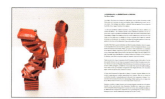

Shiro Kuramata
"Revolving cabinet"
Column furniture, 1970
Red acrylic plastic, twenty mobile trays around a central axis.
Azzedine Alaïa
Ready-to-wear Spring/Summer 1986
Top and skirt ensemble in red acetate knit, bandage skirt closed with laces at the side.
PH. STÉPHANE AÏT OUARAB

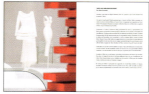

Azzedine Alaïa
Ready-to-wear Autumn/Winter 1991
Short dress in white viscose velvet and elastane knit with open-work seams, skirt with padded hem.
Azzedine Alaïa
Couture Spring/Summer 1990.
Banded dress in ecru viscose, polyamide and elastane knit, open-work effect.
PH. STÉPHANE AÏT OUARAB

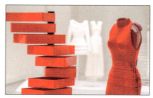

Shiro Kuramata
"Revolving cabinet"
Column furniture, 1970
Red acrylic plastic, twenty mobile trays around a central axis.
Azzedine Alaïa
Ready-to-wear Spring/Summer 1986
Top and skirt ensemble in red acetate knit, bandage skirt closed with laces at the side.
PH. STÉPHANE AÏT OUARAB

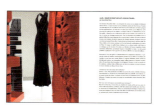

Above center
Azzedine Alaïa
Ready-to-wear Spring/Summer 2014
Long dress in black viscose and lurex jacquard knit with openwork seams.
PH. SYLVIE DELPECH

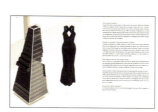

Shiro Kuramata
Pyramid drawer unit, 1968
Pyramid made of transparent acrylic; drawers made of black extruded acrylic.
Azzedine Alaïa
Ready-to-wear Spring/Summer 2014
Long dress in black viscose and lurex jacquard knit with openwork seams.
PH. STÉPHANE AÏT OUARAB

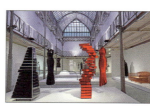

Exhibition view.
PH. SYLVIE DELPECH

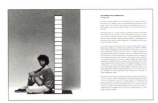

Shiro Kuramata
in 1970, with Dinah, a shelf designed the same year.
PH. TAKAYUKI OGAWA

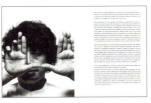

Shiro Kuramata
in 1979
PH. KAZUMI KURIGAMI

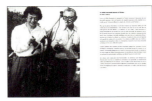

Shiro Kuramata et Ettore Sottsass
in 1987, Cap d'Antibes, Ettore Sottsass's 80th birthday.
PH. COURTESY ARCHIVIO ETTORE SOTTSASS

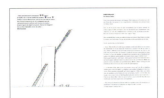

Shiro Kuramata
Drawing, "Stairs" 1980.

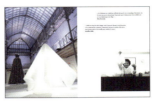

Shiro Kuramata
"Ghost Lamp" ou « Oba-Q »
Lamp, K- series S-473, 1972.
White molded plastic.
PH. SYLVIE DELPECH

Shiro Kuramata,
In his office 1983/85.
PH. TAKAYUKI OGAWA

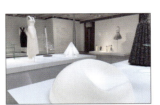

At the forefront
Shiro Kuramata
"Luminous Chair"
Armchair, 1969.

In the background on the left
Shiro Kuramata
"Illuminated revolving cabinet"
Shelf, 1973.

Top left
Azzedine Alaïa
Special creation after a Spring/Summer 1990 design.
Bandage Wedding dress in viscose knit,
overskirt in same colour silk organza.

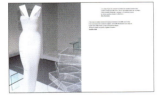

Azzedine Alaïa
Couture Spring/Summer 1990.
Banded dress in ecru viscose, polyamide
and elastane knit, open-work effect.
PH. SYLVIE DELPECH

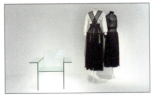

Shiro Kuramata
"Glass Chair", 1976
Glass, flat back and wide armrests (12mm).

Azzedine Alaïa
Ready-to-wear Autumn/Winter 1986
Shirt in ecru silk and polyester taffeta, skirt with
gathered panels and asymmetrical straps.

Azzedine Alaïa
Couture Autumn/Winter 1982
Long dress in black silk chiffon, skirt with gathered panels.
PH. SYLVIE DELPECH

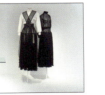

Shiro Kuramata
"Broken Glass Table"
Table, 1986
Metal and broken glass.

Azzedine Alaïa
Special creation, 2017
Structured strapless dress in multiple layers
of laser cut cotton poplin in black, white
and charcoal grey, fully topstitched.
PH. STÉPHANE AÏT OUARAB

Shiro Kuramata
Drawing, "Crackeled
glass table" 1986.

Shiro Kuramata
"Broken Glass Table"
Table, 1986
Detail.
PH. STÉPHANE AÏT OUARAB

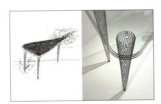

Shiro Kuramata
Drawing, « North attitude » 1985.

Shiro Kuramata
"Twilight Time"
Table, 1985.
Top made of three stacked triangular
glass plates with rounded corners.
Three conical legs in steel mesh.
PH. SYLVIE DELPECH

BOOK CAPTIONS

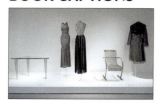

From left to right
Shiro Kuramata
"Twilight Time"
Table, 1985
Top made of three stacked triangular glass plates with rounded corners. Three conical legs in steel mesh.
Azzedine Alaïa
Couture Autumn/Winter 2001
Long dress in black and silver viscose knit with chainmail effect.

Azzedine Alaïa
Special crection, 2017
Long dress in silver metal chainmail, skirt with black chiffon inserts.
Shiro Kuramata
"Sing, Sing, Sing"
Armchair, 1935
Structure: welded steel tubes.
Seat and back: steel mes.
Azzedine Alaïa
Ready-to-wear Autumn/Winter 1991
Two-coat ensemble, the exterior in silver grey polyester lace, the interior in black polyamide fabric with wide lapel collar.
PH. SYLVIE DELPECH

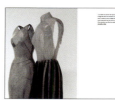

From left to right
Azzedine Alaïa
Couture Autumn/Winter 2001
Detail
Azzedine Alaïa
Special creation, 2017
Detail
PH. SYLVIE DELPECH

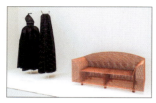

From left to right
Azzedine Alaïa
Couture Autumn/Winter 2011
Long dress with structured peplum in black laser cut velvet.
Couture Automne/Hiver 2011
Long dress in black laser cut velvet, copper leather strands.
Shiro Kuramata
"How High the Moon"
Two-seater sofa, 1986
Shaped copper coloured metal mesh, curved back.
PH. STÉPHANE AÏT OUARAB

Shiro Kuramata
Drawing, *"How High the Moon"* 1986.

Shiro Kuramata
Drawing, "Cats and *How High the Moon"* 1986.

From left to right
Shiro Kuramata
with cats, 1983 or 1984
Azzedine Alaïa
with his cat, ca. 1995

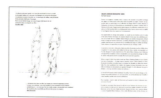

Shiro Kuramata
Drawing, *"Dream Diary"* 1986.

Shiro Kuramata
"Acrylic Stool"
Detail
PH. SYLVIE DELPECH

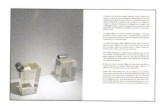

Shiro Kuramata
"Acrylic Stool"
One of a pair, 1990
Tinted acrylic, aluminium and alumite structure containing feathers.
PH. SYLVIE DELPECH

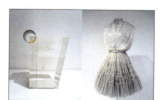

Shiro Kuramata
"Acrylic Stool"
One of a pair, 1990
Tinted acrylic aluminium and alumite structure containing feathers.
Azzedine Alaïa
Couture Spring/Summer 2009
Short dress in organza embroidered in a pattern of silver circles, belt in silver lamé leather.
PH. SYLVIE DELPECH

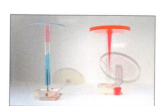

From left to right
Shiro Kuramata
"Placebo"
Occasional table. 1989
Blue and orange acrylic, round top, aluminium stem.
Shiro Kuramata
Side table, 1989
Pink-coloured acrylic, circular top.
PH. SYLVIE DELPECH

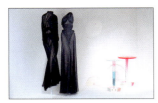

Azzedine Alaïa
Couture Autumn/Winter 1982
Long dress in black silk chiffon lined with incrustations of turquoise silk chiffon.
Azzedine Alaïa
Couture Spring/Summer 2003
Long dress in navy blue silk chiffon, asymmetrical neckline, twisted fabric on the side.
PH. SYLVIE DELPECH

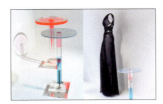

At the forefront
Shiro Kuramata
"Placebo"
Occasional table. 1989
Blue and orange acrylic, round top, aluminium stem.
In the background
Shiro Kuramata
Side table, 1989
Pink-coloured acrylic, circular top.
PH. SYLVIE DELPECH

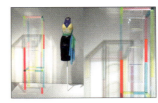

Shiro Kuramata
"Cabinet de curiosité" 1989
3-tier coloured acrylic structure (pink, green, blue).
Azzedine Alaïa
Ready-to-wear Spring/Summer 1983
Diamond shape cut-out top in electric blue, lemon yellow, mint green and turquoise silk chiffon; black lambskin leather skirt.
PH. SYLVIE DELPECH

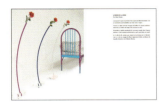

Shiro Kuramata
"Ephemera"
Flower vases, 1989
Cubic acrylic bases, aluminium stems finished with blue, purple and steel coloured alumite.
PH. SYLVIE DELPECH

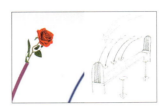

Shiro Kuramata
Drawing, *"Laputa"* ca. 1991
PH. SYLVIE DELPECH

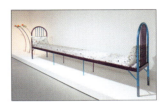

Shiro Kuramata
"Laputa"
Bed, 1991
Aluminium, purple and pink tinted alumite finish, grey legs, plexiglas bed base, silk.
PH. SYLVIE DELPECH

Shiro Kuramata
Bent glass table, 1988
Glass, aluminium support, finished with purple-pink and blue alumite.
PH. STÉPHANE AÏT OUARAB

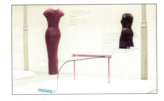

From left to right
Azzedine Alaïa
Ready-to-wear Spring/Summer 1986
Long sheath dress in magenta acetate knit.
Azzedine Alaïa
Ready-to-wear Autumn/Winter 2010
Short dress in blackcurrant silk ribbed knit embroidered with iridescent glass beads.
PH. STÉPHANE AÏT OUARAB

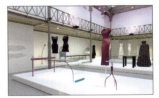

Exhibition view.
PH. SYLVIE DELPECH

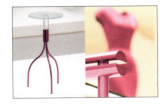

Shiro Kuramata
"Acrylic Side Table #1"
Tripod pedestal table, 1989
Glass and acrylic top, aluminium base finished with purple alumite.
Shiro Kuramata
Table, 1988
Détail
PH. STÉPHANE AÏT OUARAB

Shiro Kuramata
Table, 1988
Detail
PH. STÉPHANE AÏT OUARAB

Shiro Kuramata
"Cabinet de curiosité" 1989
Detail.
PH. SYLVIE DELPECH

ALAÏA/KURAMATA, LIGHTNESS IN CREATION

Published for the exhibition
« ALAÏA/KURAMATA, LIGHTNESS IN CREATION ».
Curated by Carla Sozzani and Olivier Saillard

Azzedine Alaïa Foundation, Paris,
from the 24st June, 2024 to the 16th February 2025

Edited by
Carla Sozzani

Art Direction
Claudio Dell'Olio

Texts
Tadao Ando, *from the book "Shiro Kuramata, Ettore Sottsass," 2010*
Andrea Branzi, *from the book "Shiro Kuramata" 1991, Hara Museum Art*
Anne-Marie Fèvre, *Interview with Azzedine Alaïa, Liberation 2 Septembre 2005*
Mieko Kuramata
Shiro Kuramata, *"Le verre, ou les indices de la lévitation - Inteview with Shiro Kuramata'", Space Modulator, N°58, February 1981.*
Riichi Miyake, *from the book "Star Piece", 1991*
Barbara Radice
Ettore Sottsass, *exhibition "Nevica sempre quando ti scrivo", Galleria Carla Sozzani, Milano, 2003*
Olivier Saillard
Carla Sozzani

Photos
Sylvie Delpech, Takayuki Ogawa,
Stéphane Aït Ouarab, Kazumi Kurigami

ACKNOWLEDGEMENTS:

The Azzedine Alaïa Foundation
sends special thanks to:
Mieko Kuramata

The Azzedine Alaïa Foundation
wishes to thank for their constant support:
La Maison Alaïa
Le Groupe Richemont

A very special thanks to:
Le Fonds de dotation Le Monde
de Leila Menchari

For the exhibition the Azzedine Alaïa
Foundation wishes to thank:
Commissariat : Olivier Saillard assisté
de Sarah Perks
Textes : Olivier Saillard
Réalisation : Ludovic Angebost
Graphisme : Claudio Dell'Olio
Aménagements : SED
Signalétique : Picto
Lumière : Luminœuvre
Mannequins : Daniel Cendron

Service Patrimoine Fondation :
Gaël Mamine, Miquel Martinez Albero,
Sarah Perks, Ariel Stark-Ferré,
Sandrine Tinturier assistés de Nicholas
Nyland, Stephanie Lever, Lisa Magliano,
Elie Pinault, Rachid El Mimouni
Restauratrice : Mylène Ducharme

FOUNDERS

CARLA SOZZANI
CHRISTOPH VON WEYHE

OFFICERS

PRESIDENT
CARLA SOZZANI

COUNCILLORS
FABRICE HERGOTT
SERGE LASVIGNES

TREASURER
UGO SUPINO

DIRECTOR
OLIVIER SAILLARD

BOARD OF TRUSTEES

COLLEGE OF FOUNDERS
COMTESSE NICOLE DE BLÉGIERS
VICTOIRE NEWMAN
CARLA SOZZANI
UGO SUPINO

COLLEGE OF QUALIFIED PERSONALITIES
JEAN-LOUIS FROMENT
FABRICE HERGOTT
SERGE LASVIGNES
PIERRE PROVOYEUR

COLLEGE OF INSTITUTIONAL PARTNERS
MUSÉE DES ARTS DÉCORATIFS, JOHANNES HUTH
THE METROPOLITAN MUSEUM OF ART, ANDREW BOLTON

COLLEGE OF FRIENDS OF AZZEDINE ALAÏA
ANNA COLIVA
GIOVANNI FRAU

COLLEGE OF PATRONS
PARTNER PATRON: RICHEMONT INTERNATIONAL SA, ANNE DELLIÈRE
PARTNER PATRON: FONDATION CARTIER POUR L'ART CONTEMPORAIN, RICHARD LEPEU
ACTIVE PATRON: KRIS RUHS

COLLEGE OF EX OFFICIO MEMBERS
NICOLE KLEIN

SECRETARY GENERAL
FRANÇOISE GUITTARD

Published in 2025 by Damiani Books
in collaboration with
Fondation Azzedine Alaïa

Copyrights
© 2025 Fondation Azzedine Alaïa
© 2025 Photographs, the Photographers
© 2025 Texts, the Authors

DAMIANI
info@damianibooks.com
www.damianibooks.com

All rights reserved. No part of this publication may be reproduced or transmitted in any form or by any means, electronic or mechanical - including photocopying, recording or by any information storage or retrieval system - without prior permission in writing from the publisher.

Printed in January 2025, Italy
ISBN 978-88-6208-838-1

Front and back cover:
photo by Sylvie Delpech